How to Make
50 Fabulous Flat
Kumihimo Braids

How to Make
50 Fabulous Flat
Kumihimo
Braids

Beth Kemp

Search Press

A QUARTO BOOK

For Belinda, Emma, Angie, Andrea, Megan and Janine

Published in 2016 by
Search Press Ltd
Wellwood
North Farm Road
Tunbridge Wells
Kent TN2 3DR

Copyright © 2016 Quarto Publishing plc

All rights reserved.
No part of this publication may be reproduced, stored in a retrieval system or transmitted in any form or by any means, electronic, mechanical, photocopying, recording or otherwise, without the written permission of the copyright holder.

ISBN: 978-1-78221-380-2

Conceived, designed and produced by:
Quarto Publishing plc
The Old Brewery
6 Blundell Street
London N7 9BH

QUAR.FMKB

Editor & designer: Michelle Pickering
Senior art editor: Emma Clayton
Illustrator: John Woodcock
Photographer: Phil Wilkins
Art director: Caroline Guest

Creative director: Moira Clinch
Publisher: Paul Carslake

Colour separation by
Bright Arts Ltd, Hong Kong
Printed by
1010 Printing International Ltd, China

6	Foreword		
6	About This Book		

8 Chapter One: Getting Started

10	Kumihimo Square Plate	15	Designing Flat Braids
11	Findings	16	Basic Techniques
12	Threads	22	Starting and Finishing
14	Beads		

28 Chapter Two: Projects

30	My First Friendship Bracelets	84	Chequerboard Choker
32	Funky Sneaker Laces	86	Lacy Wired Necklaces
34	Tutti-Frutti Bracelets	88	Gilded Dragonfly Ensemble
36	Orange Sherbet Bracelet	90	Emerald Princess Necklace
38	Pansy Eyes Necklace	92	Harvest Moon Choker
40	Peppermint Leaves Ensemble	94	Blue Bling Bead Necklace
42	Blue Ice Bracelet	96	Carnival Necklace
44	Cool Green Bookmark	98	Royale Necklace
46	Strawberry Kisses Lariat	100	Amber Eyes Necklace
48	Grapevine Choker	102	Shimmering Princess Woven Collar
50	Golden Dreams Necklace	104	Pretty Bubbles Necklace
52	Rainforest Necklace	106	Symphony of Pearls Necklace
54	Fairy Meadow Necklace	108	Purple Genie Necklace
56	Red and Gold Bookmark	110	Magical Dragon Bracelet
58	Sonata Ribbon Necklace	112	Glitz and Glamour Necklace
60	Jewel Cuff	114	Waterfall Bracelet
62	Blue Skies Chevron Braid	116	Goddess of Dawn Necklace
64	Sunshine Necklace	118	Dancing Fans Necklace
66	Quilted Ensemble	120	Sunset Splendour Necklace
68	Three Quilted Variations	122	Blue Sea Urchin Bracelet
70	Rickrack Bookmark	124	Forest Glen Ensemble
73	Jazzy Jewels Necklace		
76	Long and Short Zigzag Necklace		
78	Crazy Zigzag Necklace	127	Index
81	Flame Interlaced Necklace	128	Credits and Template

Foreword

My love of braiding and beading comes from a background in the prestige jewellery industry. About twelve years ago, I was introduced to kumihimo by international guru of braiding, Makiko Tada from Japan. I now hold classes and workshops in Brisbane, Australia.

My fascination for kumihimo has inspired me to develop my own designs for the kumihimo disc and plate, and to write two earlier books, called *How to Kumihimo* and *Twist, Turn & Tie: 50 Japanese Braids*.

With the advent of the kumihimo round disc and square plate, braiding can be done by anyone, any age, anywhere. Kumihimo is one of the few crafty things that can be taken on board a plane.

The luscious silks, unusual beads and fabulous fittings that are available are just waiting to be transformed into unique fashion accessories, either as jewellery, a belt or something for the home. The possibilities are endless.

My aim with this book is not only to inspire you with the 50 projects and beautiful photographs, but also to give you a reference book that unlocks the mysteries of Japanese braiding on the square kumihimo plate. I hope you enjoy making the projects as much as I have loved creating them.

Happy Braiding,

Beth Kemp

Check out my newsletter 'Kumi Kapers' on my website www.braidandbeadstudio.com, and Facebook pages 'How to Kumihimo with Beth Kemp' and 'How to Make 50 Fabulous Kumihimo Braids'.

About This Book

This book offers a wonderful collection of flat braid projects created on a kumihimo square plate. Core information at the beginning introduces the plate, threads, beads and findings, with key techniques explained step by step. This is followed by the project section, organised into plain, zigzag, wire and beaded braids. The plain braids use progressively more slots on the kumihimo plate, so that you can gradually gain confidence handling more and more threads while trying different types of braiding designs.

CHAPTER 1: Getting Started (pages 8–27)

This section introduces you to the kumihimo square plate and the many types of threads and beads. There is guidance on designing your own flat braids and tips for calculating the amount of thread and beads you will need before you begin. The step-by-step instructions walk you through the key techniques, from threading the plate and adding beads to finishing off with a range of findings.

Step-by-step techniques
Step-by-step photographs and instructions explain the basic techniques of working a flat kumihimo braid, including different methods of starting and finishing the braid. Take the time to read this chapter before starting the projects, and then refer back to it whenever you need to.

CHAPTER 2: Projects (pages 28–126)

Projects start with some friendship braids suitable for complete beginners. Once you have mastered the basics, you can move to any project in the book.

Be a better braider
There are plenty of tips to accompany each project.

Skill level
Projects are graded by skill level from one to three; one is for beginners, and three is for accomplished braiders.

Starter plate and template
A cardboard plate is provided with this book to get you started. There is also a template on the last page of the book that you can use to make more cardboard plates.

Diagrams
Each diagram shows the position of the threads before the move is made; red arrows indicate the direction in which the threads travel.

Beaded braids
Before tackling a beaded project, it is a good idea to make the equivalent plain braid first. Once you have mastered the moves, it will then be easy to incorporate beads.

You will need
Dimensions of thread are listed, along with findings and bead quantities, when required. Kumihimo threads are specified as sections, because they are sold in ropes containing four sections. Other threads are specified as lengths. Many of the projects also suggest an alternative type of thread you can try.

Front & back
Where appropriate, each project shows which is the front and back as used in the finished sample. For some braids, it is obvious. For others, you will pick the side that you like best.

Plate set-up
The first diagram shows the starting position of the threads, and which threads have beads, if appropriate.

Finishing suggestions
Follow these instructions if you want to finish the braid in the same way as in the photograph. The approximate length and width of the sample braid is provided.

Adding the beads
The beading techniques used in the projects are explained step by step on pages 20–21, and some projects also feature helpful reminders with close-up diagrams of the beading method used for that project.

Getting Started

This chapter describes the kumihimo square plate, plus the threads, beads and findings that are used to make the braids in this book. The basic techniques of braiding, including adding beads and the different methods of starting and finishing, are explained step by step to help you get the best results from your very first braid.

Kumihimo Square Plate

The original kumihimo square plate was designed by Makiko Tada of Japan as a modern, portable way to make very flat kumihimo braids.

Flat kumihimo braids are traditionally made on a wooden stand called a *takadai* (ta-ca-dye) that is used for making flat, obliquely interlaced braids. The braider sits within the stand, which is about the size of a small desk. It requires other equipment, such as *tama* (wooden weighted bobbins) and a wooden sword to gently beat the threads into place. The *takadai* dates back to the Edo period between 1603 and 1868.

There are two designs of square kumihimo plates available worldwide. The Hamanaka plate used to make all the braids in this book is 15cm (6in) square, made of high-density foam 1cm (⅜in) thick and has a 35 x 17mm (1⅜ x ⅝in) rectangular hole at the centre. It has a total of 32 slots, with 12 numbered slots at the top and bottom, and 4 lettered slots on each side. The numbers at the bottom and the letters on the right are in circles to make it easier to follow the instructions. The instructions for all the projects in this book are written for this plate.

The other square plate readily available is by Beadsmith. It is 14cm (5½in) square and has 10 slots on each of the four sides. These are marked with numbers 1 to 10 at the top and 11 to 20 at the bottom, and letters A to J on the left and lowercase a to j on the right. The hole is approximately the same for both plates.

The slots in both types of plate hold the threads gently and firmly in place during braiding, providing the tension required for braiding, although you may find it helpful to use weights as well (see panel opposite). It is a good idea to keep a separate plate for very fine work, and another for materials that might damage the slots, such as wire or very thick thread. The hole in the centre is for the braid to go through. It also dictates the width of the finished braid, although, because the braids are usually very thin and flat, braids slightly wider than the hole can also be made.

The cardboard plate provided with this book is 12cm (4¾in) square. So that the projects in this book can be easily worked on this smaller plate, the numbers at the top and bottom are only from 2 to 11, with 6 and 7 still in the middle positions as on the Hamanaka plate.

Cardboard plates are an inexpensive way to start the braiding experience, and there is a template for this in the back of the book if you wish to make your own.

There is also a round disc available for making round, square, flat, spiral and hollow braids (see page 128).

Findings

There is an excellent range of end fittings and clasps available for flat kumihimo braids. The choice is yours, from plain and simple to glitz and glamour, but choose good-quality findings for a professional look.

Japanese flat end sets (1)
Traditional Japanese end crimps designed specifically for flat braids are perfect to finish either a bracelet or neckpiece. They feature a ball-and-socket clasp, and are available in various finishes and sizes, either assembled or as individual components. They are of superior quality and will not tarnish, although they are quite narrow.

Rectangular end sets (2)
There is an extensive range of beautiful end cap sets suitable for kumihimo flat braids. These are available either plain or set with rhinestones, and often have a magnetic closure. Once fitted to the project, they can have the appearance of a bead rather than a clasp. They come in a huge range of colours, sizes and quality.

Round end sets (3)
End cap sets for round braids can be used with flat braids. Again, they are available in many styles and colours as well as quality. When fitting them, make sure there are no gaps between the braid and the metal on the right side of the project.

Self-assembled findings (4)
Some of the end fittings that can be purchased separately are excellent. This gives you the freedom to select a particular type of clasp for the project. The self-assembled end crimps used with the projects in this book are slightly wider than Japanese ones and have sharper teeth to grip the braid firmly. Available in many colour finishes, they can be an economical way to finish the braid. Not all findings of this nature are tarnish-resistant, though.

Tools and materials

You will most likely already have tools such as scissors, a tape measure and sewing needles, but you will also need the following:

Bobbins
The best bobbins to use are E-Z Bobs because they keep the thread tangle-free and beads secure. They are available in small (4.5cm/1⅞in), medium (6cm/2½in) and large (9cm/3½in). Made of soft plastic, they are a clam shape that opens so threads can be wound on. It is only necessary to use bobbins when the threads are more than 1m (1yd) long or if using beads.

Strong thread for whipping
Whipping thread will not be seen once it is glued into the end fitting, but using the wrong type could result in the braid coming undone before the end caps are fitted. Hand-quilting thread is ideal because it is a polyester-based cotton. You could also use a strong beading thread such as Nymo.

Glue
It is important to choose a craft glue that dries clear and is strong enough to hold the braid inside the end caps. My choice is Helmar Premium Craft Glue or E6000. If you have doubts, test it first.

Beading tools
A beading board allows beads to be easily sorted and picked up with a beading needle. General beading tools like round- and flat-nose pliers, wire cutters, a bead scoop and thread cutters can be useful for beaded braids, opening and closing jump rings, and assembling end fittings and clasps.

Beading needles
The size of the needle is dictated by the hole in the bead that it has to go through. It is also handy to have a large-eye tapestry needle available to weave the threads back into the braid, if necessary.

Weights
Weights for kumihimo can be the beautiful *tama* used with traditional looms, or simply a couple of fishing sinkers. If you feel the need for weights when using the plate, select the type that gives the result required, and remember there needs to be a counterweight on the braid for balance.

1 2 3 4 5 6 7 8 9 10

Threads

Flat kumihimo braids can be made with just about any fibre or thread. The aim of this section is to help the beginner with the different threads used in this book.

Generally speaking, stiffer threads such as rattail or satin cord are best suited to flat braids. Many of the projects also suggest an alternative thread that you could try. My advice is to use the thread in the 'You will need' listing before experimenting with different types, textures and alternative colour placements.

Traditional kumihimo thread (1–4)
Traditional kumihimo thread is available as Fine Silk (1) and Premium Silk, as well as a synthetic version called Imposter or Biron (2). It is also available in metallic (3) and metallic sparkle (4) ranges. The non-tarnishing metal is wrapped around the tiny individual threads, forming a solid or variegated colour. The metallic sparkle is a silk thread with metallic sprinkled on top. The colour choice is amazing.

Rattail or satin cord (5)
This type of thread is readily available in a fantastic range of colours. It is easy to use, has a beautiful sheen and is available from general craft shops either in rolls or by the metre. The stiffness of the central core varies with the quality of thread, and this will determine the overall stiffness of the braid. It comes in different thicknesses, although not very accurately measured. The braid sample opposite (15) made using 2mm rattail (5), for example, works up more like a 3mm cord, simply because the core of this particular cord was fairly stiff. The majority of projects in this book use 1mm cord with a soft core.

Nylon braiding cord (6)
Nylon cord is available in skeins and rolls, making it very economical and easy to use. It comes in a huge range of mostly solid colours and thicknesses. Nylon cord is ideal for the beginner to make some simple and fun projects, such as the pretty friendship bracelets or bookmarks in this book. The very fine cord is great for use as a beading thread because it is more flexible than threads like C-Lon and S-Lon, although these can be used as a substitute.

Hand-dyed embroidery silk (7)
Some projects in the book use hand-dyed silk embroidery thread by Colour Streams. Exotic Lights (7) is the equivalent of pearl cotton #3. It comes in many colours and has a high twist and medium lustre. It comes in skeins of 8m (8¾yd).

Ophir is a finer silk thread equivalent to pearl cotton #8 and available in 15m (16½yd) skeins. It has a high lustre and

THREADS 13

Using kumihimo thread

Imposter/Biron synthetic kumihimo thread and both types of metallic kumihimo thread have been used for several projects in this book. These threads come in ropes consisting of four sections, all 2.7m (105in) long. Each section is made up of approximately 39 individual threads. Here are some tips for working with kumihimo thread:

- Take your time, don't rush and have good lighting.
- Undo the knots at each end of the rope to separate the four sections.
- Place each section straight across the plate, tie together at the centre with a lark's head knot to form a neat end (see page 23) and wind on to bobbins.
- To cut the sections in half to have lengths of 135cm (52½in), tie a knot in both ends before you cut.
- To separate a section into fewer individual threads, first smooth the section and then carefully pull the required number of threads laterally from it. Should the threads tangle, stop, smooth out and start again.
- During braiding, smooth each section by running it between your thumb and index finger, like smoothing hair in a ponytail. You may have to repeat this process several times. Be patient and work slowly.

The photograph below shows a rope of kumihimo thread knotted at the end, and then the four sections separated out, ready to go straight on to the kumihimo plate. The individual tiny threads are clearly visible.

high twist, making it quite strong for beaded braids. Both of these silk threads are easy for beginners to use.

Textured thread (8)
Textured threads are a great way to add interest to a plain braid. There are several brands available in different parts of the world. Textures by Colour Streams has been used in this book. Each skein consists of eight 200cm (80in) lengths of different textural threads, making it very easy to use for braiders of all levels.

Ribbon (9)
Soft, hand-dyed, variegated nylon ribbon, approximately 20mm (¾in) wide, with a metallic thread through it has been used in this book. The particular colours used came in an 11m (12yd) length.

Wire and tigertail (10)
Round beading wire comes in a range of sizes and colours. Two sizes have been used in this book: 28 gauge and 30 gauge.

Tigertail (10), normally used for beading, is fantastic for Japanese braiding. Because it is nylon-coated stainless steel wire, it is easier on the hands and gives a more even result than regular round beading wire.

Sample braids (11–16)
These six-warp braid samples demonstrate the width of braid produced by different threads: 1mm nylon cord = 5mm (³⁄₁₆in) wide (11); 1mm rattail = 6mm (¼in) wide (12); Imposter/Biron kumihimo thread = 6mm (¼in) wide (13); 2mm nylon cord = 8mm (⁵⁄₁₆in) wide (14); 2mm rattail = 10mm (⅜in) wide (15); and Exotic Lights hand-dyed silk = 4mm (³⁄₁₆in) wide (16).

Beads

There is a treasure trove of beads available to incorporate into kumihimo braiding. The styles and colours are amazing.

Choose the type of bead that gives the effect you are after. Irrespective of which bead you choose, the thickness of the thread is dictated by the size of the hole in that particular bead.

Seed beads (1–3)
The most common sizes for braiding are from the very small size 11 up to the larger size 6 – the higher the number, the smaller the bead. There is a huge variation in the quality of these beads, particularly the cleanness of the hole. It is worth using the Japanese brands of seed beads as they are of the highest quality with uniform shaping. The most commonly used seed beads are round (1), but other shapes include triangle (2) and the gorgeous drop-shaped magatama beads with off-centre holes (3). Seed beads are available in numerous finishes, including C/L (colour lined – a clear bead with a coloured lining), S/L (silver lined – the hole is lined with silver), AB (aurora borealis – a rainbow finish) and transparent (you can see through the colours).

Czech glass beads (4–5)
These are also of excellent quality and include some unusual shapes, including daggers (4) and Rizo (5), which are shaped like a grain of rice.

Pearls (6)
Pearls can be braided as a string or used individually. As the hole size in pearls is usually very small, they require very fine thread or traditional pearl stringing thread, which is then incorporated into the braid.

Semiprecious beads (7–8)
There are many types and shapes of semiprecious beads available. Examples include gemstone, such as tanzanite (7), and glass, such as millefiori (8). These could be round, oval, flat, paddle shaped or chips, and can be added one at a time, in groups or as strings.

Pendants and large-holed beads (9–10)
Pendants, tube beads (9) and other large-holed beads (10) are great for quickly adding a little bling to your project. Rhinestone beads add lots of sparkle.

Designing Flat Braids

This can be as easy as changing the number of colours and the way they are set up before braiding commences.

The more colours used in a woven or zigzag braid, the more interesting it becomes. Instead of the one colour used for the Rickrack Bookmark (page 70), for example, try making it using four different colours. With the Cool Green Bookmark (page 44), use five colours instead of two.

If you want to have a specific colour or bead pop up in a particular design, label the bobbins of thread with their starting slot and make a test run. That way you can easily see which threads need the beads and which to keep plain. Don't forget to make a note of the layout so you can make it again.

Calculating braid length
The length of braid is determined by the finished item you wish to make, but remember to take the length of the end fitting into account when deciding how long a braid needs to be. This is especially important for bracelets and chokers.

Calculating length of thread required
The length of thread for the majority of projects in this book is double the finished length. This means that for a six-warp braid 50cm (20in) long, each warp will need to be approximately 100cm (40in) long. As you progress through the book and are increasing the number of warps and the complexity of the pattern, the lengths will be greater, even up to four times the finished length. Therefore, it is important to make a sample braid first.

Estimating the number of beads
To calculate the number of beads needed for a particular project, thread 10 beads on to each of the threads that are to have beads – in the example below, four beaded threads – and braid until they are used up. If there are four threads each with 10 beads making a 5cm (2in) braid, the calculation for a 50cm (20in) braid will be as follows:

What is a warp?
Once the threads are set up in the starting positions on the kumihimo plate, they are referred to as warps. The length of the warp is taken from the centre hole to the end of the thread. For a braid with a neat end start (see page 23), the warp will be half the starting length of thread. For a plaited loop start (see page 24), each warp is the starting length less about 5cm (2in) used for the plaited loop, then half of this.

Things to make with braids
- **Jewellery**, including necklaces, bracelets, earrings and brooches.
- **Scissor keepers** – braid straight on to the scissor handle or use a loop or finding, and finish with a tassel.
- **Bag tags/ties** to use as identification or decorative strap for a camera or smart phone.
- **Key rings**, either with a finding or a loop – a great way to use up any excess braids.
- **Belts** – either braided or tied using macramé techniques.
- **Curtain ties** made with several braids plaited together. Flat braids are ideal for this.
- **Shoelaces** – use fine braids to make fun shoelaces in the team colours.
- **Bag handles** – especially beautiful for handmade felted or crocheted bags.
- **Lanyards** for reading glasses and sunglasses.
- **Decorative knots or frogging** for handmade clothing or furnishings.
- **Decorations** – wind a really long braid around a foam shape, such as a bell, for holiday decorations.
- **Bowls or plant holders** – wind a really long braid into a bowl shape or around a pot.

ESTIMATING THE NUMBER OF BEADS

4 threads × 10 beads = 40 beads

÷ 5cm (2in) × 50cm (20in)

will need 10 × 40 = 400 beads divided evenly across four beading threads.

Basic Techniques

The following techniques will assist you in making the most of your braiding experience and will become a reference tool as you progress with making beautiful braids on the kumihimo plate.

Setting up and holding the plate

This example shows the plate being set up to make a chevron braid with thread in six positions. This one is started with an overhand knot (see page 18), but all the braids use the same principle for setting them up. The braid emerges beneath the rectangular hole in the centre of the plate.

1 Tie six lengths of thread together at one end with an overhand knot. Place the knot in the hole of the plate and slot the threads into the required starting positions.

Method 1: Plate resting on left hand. ▼

2 Hold the knot under the plate with your left thumb and forefinger, making sure the threads are held firmly in the slots and lying flat against the plate.

3 There are different ways of holding the plate. My preference is to hold the braid itself under the hole, with the plate resting on my left index finger and the other fingers balancing the plate. This leaves the right hand free to make the moves. I feel that holding it in this way gives better control over the braid. However, you may prefer to hold the actual plate and, if you are left-handed, you may prefer to hold the plate with your right hand. Note that the plate is always held the right way up and is only rotated for zigzag braids.

Method 2: Holding plate with left hand. ▶

Tips

- **Using bobbins:** E-Z Bobs are used to keep the working threads tangle-free. Open the bobbin, wind the thread smoothly and evenly around the centre and lock it in place by closing the bobbin. Wind the bobbins so they hang just under the plate.

- **Point of braiding:** The point of braiding is where the threads actually cross at the centre hole. Become familiar with the way this looks because it will help you recognise if a mistake has been made as well as the last threads moved.

- **Made a mistake?** Simply reverse the moves one at a time back to the mistake – follow the diagrams in reverse to make the process easier – then correct it and continue on.

- **Stopping and starting:** Have to leave your braiding partway through? No problem. Always complete the entire sequence of moves and then, when you return, start from the first move of the sequence.

- **Rotation:** For zigzag braids where the plate is rotated 180 degrees, the numbers will be upside down. There will be a sequence of moves made with the plate right way up, followed by a sequence of moves with the plate upside down. This is how the 'zig' and 'zag' angles are formed.

BASIC TECHNIQUES 17

Working the braid

The same technique applies to both foam and cardboard plates, although foam plates are easier to hold and more durable. It is good practice to keep one plate for very fine braids and another for thick threads or wire because, over time, these can loosen the slots. The square plate has numbered slots at the top and numbers in circles at the bottom. The sides have letters on the left and letters in circles on the right.

1 Using your free hand, lift the threads out of the slot, as close to the plate as possible.

2 Place the thread in the destination slot, keeping the thread taut. The point at which the threads cross at the hole in the plate is called the point of braiding.

Right hand kept free to move the braiding threads

Destination slot

Point of braiding

Left hand holds or supports the plate

Re-tensioning the thread

The point of braiding tends to move against the back edge of the hole. If it is pulling too much, loosen the threads on the top of the plate and gently pull the threads on the bottom to bring it back into place.

1 Using your free hand, loosen the threads at the top of the plate.

2 Tighten the threads at the bottom of the plate until the point of braiding is central in the hole. Adjust the top threads again, if necessary, until all threads are taut across the plate.

18 GETTING STARTED

Functional knots

There are three everyday knots that are very useful in Japanese braiding. The overhand and lark's head knots can be used to start or finish your braids (see pages 22–23), so it is worth learning the techniques. The reef or square knot is used when joining lengths of beading thread or for threading beads using a leader thread (see opposite).

Overhand knot

This is a basic knot and is often used for tying the threads together at one or both ends. It is also used as a temporary knot to secure the ends of the braid prior to finishing with end caps or a tassel.

1 Take the short end of the threads and loop them over the main length.

2 Pass the short end through the back of the loop just formed.

3 Tighten the knot as close to the short end of the threads as required for the particular project.

4 If the finished overhand knot is to be on show, take care with the wrap of the colours and the threads in the knot.

Lark's head knot

This knot is used to tie the middle of the threads together to form a neat end when finishing the braid with end caps.

1 Fold a 20cm (8in) scrap piece of thread in half, loop it around the threads and then pass the tails through the loop just formed.

2 Pull the tails to tighten the knot. The ties will go into the hole of the plate and will be discarded later.

BASIC TECHNIQUES **19**

Reef or square knot

This is a strong flat knot that is ideal for making a leader thread for threading beads (see right). It is also used when two lengths of beading thread need to be joined to create a longer piece. In addition, it can be used to join really fine braiding thread where a bead will cover the join, or the join can be worked into the braid.

1 Pass the right-hand thread over the left, and then pass the left-hand thread over the right.

2 Pull each pair of thread ends to tighten the knot.

3 The end result will be a strong, flat, neat knot.

Threading beads

Select the braiding cord or thread that best matches the size of the hole in the beads and the colour of the beads (a contrast colour is used here for clarity). Set up the plate with the threads in the starting slots before threading the beads.

Using a needle and leader thread

1 Use this technique when the braiding thread is soft, such as embroidery silk, or when it will not fit through the eye of a needle. This method is also useful when threading smaller seed beads. Thread a beading needle with a short length of strong beading thread and join it with a reef knot to form a loop (see left). Move the knot to the side of the loop away from the needle and where the braiding thread will be. Loop the braiding thread through the leader thread.

2 Pick up the beads with the needle, and slide them over the leader thread and on to the braiding thread.

Threading beads directly on to cord

This technique is ideal when the braiding thread has a bit of body, such as rattail or nylon braiding cord. Cut the end of the cord at an angle to make a point. Paint the end of the cord with clear nail varnish, run the end between a thumb and forefinger to remove excess varnish and then set aside to dry. Repeat if necessary. Once completely dry and stiff, thread the beads straight on to the cord.

Tips

- Sort the beads into equal groups, one for each thread that is to have beads. For example, for a braid with six threads and beads on all of them, you will need six groups of beads. For the projects in this book, the exact number of beads is given wherever possible.
- Thread the beads in lots of 10 so it is easy to keep track of the number of beads used.
- Wind the beaded threads on to bobbins as you go, but not too tightly. Allow room for the beads to move.

Adding beads to a braid

When you are ready to start adding beads to the braid, move 5 or 10 beads on each beaded warp free of the bobbin, ready to be incorporated into the braid. This allows you to keep a check on the beads used. As a general rule, when the first thread runs out of beads, all other beaded threads should only have one bead left, although it depends on the particular pattern being worked.

Releasing beads one at a time

This is the most common method of adding beads used in the projects. A single bead is released every time a beaded thread is moved from one specified slot to another. Subsequent thread placements then lock the bead in place. In this example of a six-warp chevron braid, there are two beaded threads, and the beads are released one at a time on opposite sides to produce a braid with beads on the outside edges only. However, the same technique can be used to release beads at any position within the braid, including releasing a bead on several beaded threads one after the other, leaving a row of beads right across the braid.

1 With your free hand, pick up the beaded thread and move it to the specified slot (here, from A up to 5), allowing one bead to drop down the thread as you do so.

2 The bead should rest at the point of braiding as you complete the move.

3 The bead will be locked in place by the following thread placement (here, from 7 over to A). Note how the bead tucks under this thread.

4 Hold the bead or beads in place with the nails of your thumb and forefinger as you continue braiding.

5 Use the same process to incorporate more beads as instructed for the project. Here, beads are released on the right-hand side of the braid as Ⓐ is moved up to 9.

BASIC TECHNIQUES 21

Releasing multiple beads

This method is called 'laying the beads' and is used when several beads are to be released on a single beaded thread. This example is a six-warp woven braid with two beads at a time released on the same thread. The beads are laid across the braid and then locked in place with subsequent thread placements. In this example, a series of up and down moves of the non-beaded threads between the top and bottom of the plate are used to separate and secure the beads within the body of the braid.

1 With your free hand, pick up the beaded thread and move it to the specified slot (here, from B across to Ⓑ). Allow the required number of beads to drop down the thread as you do so (in this case, two beads).

2 The released beads should lay across the point of braiding as you complete the move. In this example, the next move is from 6 down to B. This thread sits behind the two beads, which are not locked in place until the next sequence of moves.

Tips

- Start and finish beaded braids with a section approx. 1cm (½in) long without beads. Once braiding is complete, these unbeaded sections will be fitted inside end caps or crimps.
- The beads should sit correctly either between the threads or on top of the braid, depending on the design being worked.
- Don't allow any beads to go into the slots of the plate because they will damage them.
- Always follow the instructions for the bead release as described for the individual projects, as each braid requires beads to be released and locked into place using moves specific to that braid.
- When using the side slots, particularly with beaded and zigzag braids, use the slots that the threads prefer. If the move to the side is better placed in slot A than in slot B, then use it even if the instructions recommend B.

3 The beads are now locked in position with a series of up and down moves, with the first two threads passing to the right of the first bead, and the second two to the right of the second bead. The moves made are: **BEAD** [⑦ to 6; 7 to ⑦] **BEAD** [⑧ to 7; 8 to ⑧].

4 Moves from B across to Ⓑ and 6 down to B complete the sequence, securing the beads within the body of the braid and moving the threads into position for releasing the next row of beads.

Starting and Finishing

There are several ways to start and finish a braid to give it a professional look, and this is determined before braiding commences.

Decide how the final braid is to be used and how it will work before the plate is set up. For example, a braid that will be made into a necklace with end caps and clasp can be started with a neat end, whereas the same necklace to be finished with tassels will start with an overhand knot to be made into the tassel at the finish.

Starting with an overhand knot

This technique can be used for braids with lots of colours or odd numbers of colours, or if the braid is to have tassels. It is also used if the threads are of a particular length and a longer braid is required – for example, when using kumihimo threads that are 2.7m (105in) long and the finished length of the project is more than about 70cm (28in). This start will allow the finished braid to be up to approximately 120cm (48in).

Starting and finishing with an overhand knot

This is the easiest way to start and finish a braid.

1 Tie all the braiding threads together at one end with an overhand knot (see page 18).

2 Place the knot in the hole of the plate and, keeping hold of the knot, position the threads into the required slots on top of the plate.

3 When the braid is finished, hold the braid firmly under the plate at the finish point to keep it from coming undone while you remove the threads from the plate.

4 Remove the threads from the slots and slip them through the hole in the plate. Tie the threads at the finish end with another overhand knot to secure the braid.

STARTING AND FINISHING 23

Starting with a neat end

This is another very easy way to start a braid, making the starting end of the braid perfect for fitting straight into an end cap or crimp. The threads are tied in the middle at the hole in the plate, and the tie is removed after braiding for adding end fittings. Note that there are only three lengths of thread to make a six-warp braid using this technique. Where possible, this technique has been used for the projects in this book. You can tie the threads together first and then position them across the plate, but most of the time it is easier to position the threads on the plate and then tie them together as shown.

1 Place each length of thread across the plate in their starting positions, with the midpoint of the thread across the hole in the plate.

2 Using a scrap thread approx. 15cm (6in) long, tie the braiding threads together with a lark's head knot at the hole (see page 18). Thread the tails of the scrap thread through the hole and hold them under the plate to start braiding.

Finishing with a connector bead

Any type of bead can be used as long as the hole is large enough and long enough for both ends of the braid to go into it. The diameter of the hole would be the same as if you were to use end caps. This is a good way to finish a bangle or something that does not need to open.

1 Remove the tie from the neat end start, apply some glue and insert the braid halfway into the bead, just as you would when fitting end caps (see page 26).

2 Whip around the finish end of the braid using strong thread. Trim, apply some glue and fit into the other side of the bead. Push the two ends of the braid so that they come together inside the bead. Set aside to dry.

24 GETTING STARTED

Starting with a plaited loop

A plaited loop is often used to form a fastening loop for friendship bracelets. It can be made with or without whipping. The projects specify if whipping should be added.

Plaited loop without whipping

1 Place the threads on the plate with the midpoint across the hole. Place the threads into the middle slots at the top of the plate; leave the bottom of the threads free.

2 Plait for approx. 7.5cm (3in) so that the midpoint is across the hole of the plate. You can hold the plate with your knees to leave your hands free for plaiting. To make a three-element plait, some of the threads will need to be grouped and treated as one.

3 Fold the plait in half and remove it from the plate. Now for the tricky part: keeping hold of the plait, place the loop in the hole and position the threads in the starting slots. Continue to hold the base of the loop for the first few moves to prevent it from collapsing.

Plaited loop with whipping

1 Make the plaited loop as described above (steps 1–2). Fold the plait in half and remove it from the plate. Lay a loop of scrap thread, approx. 20cm (8in) long, on top of the plait, as shown with the red loop.

2 Using one of the threads from the back of the plait (here, turquoise), whip around the plaited loop and scrap thread while holding it all firmly. The whipping should be done from the base of the loop up towards the fold in the loop.

3 Tuck the tail of the whipping thread into the loop of the scrap piece. Pull the two tails of the scrap piece so it pulls the turquoise thread through the whipping. Discard the scrap thread.

4 Place the loop into the hole of the plate as described above (step 3) and hold the whipping for the first few moves.

STARTING AND FINISHING 25

Starting with a knotted fastening loop

Two spaced knots
This technique produces a simple loop for another knot at the finish end of the braid to go through. It is perfect for friendship bracelets because no fittings are required. Tie the threads together close to one end with an overhand knot (see page 18), and then tie a second knot leaving a space of approx. 2cm (¾in). Use a pencil or chopstick to get the spacing right.

Simple knotted loop
This is another easy start for a friendship bracelet. Fold the threads in half and tie them together with an overhand knot (see page 18) no more than 2.5cm (1in) from the fold.

Finishing with plaited tails

This finishing technique is ideal for friendship bracelets with any type of fastening loop, and is both decorative and functional. Separate the threads at the finish end of the braid into two groups. Plait each section for approx. 4cm (1½in) before tying each end with an overhand knot (see page 18). Trim the ends to suit. To wear the bracelet, twist each plaited tail around and through the fastening loop to secure.

Finishing with a double overhand knot

A double overhand knot is handy if a regular knot is too small for the fastening loop, or as a beautiful and practical way to finish off very fine braids. In this example, the working thread represents the braid.

1 Make a double overhand knot by making a loop and then taking the working thread through the loop twice.

2 Tighten the knot by easing or rolling it up to the end of the braid to make a little ball. The finished knot will be flat on the back of the braid and raised on the front.

Getting Started

Finishing with flat end crimps

Flat end crimps are a fast way to give the braids a professional finish. It is easiest if a knot has been tied at the finish end when removing the braid from the plate.

1 At the start end, discard the scrap thread from the neat end (see page 23), apply some clear craft glue, and fit the end into the crimp. (If the braid was started with an overhand knot, you will need to whip around the start end first, as described in step 3.)

2 Use flat-nosed pliers to squeeze the crimp closed, making sure no glue shows.

3 Whip around the finish end of the braid with a strong thread such as hand-quilting thread. Do this several times. Apply a dab of glue to the whipping to help it stay in place. When adding flat end crimps to a wide braid, you may need to stitch the finish end of the braid, rather than whipping around it, to keep it nice and flat.

4 Trim the excess threads by cutting close to the whipping. Don't cut the whipping thread or both it and the braid will unravel. Apply glue to the cut end and fit into the remaining crimp. Set aside to dry completely.

Finishing with end caps

Another quick and easy way to finish your beautiful braid is to fit end caps. First, separate the two ends of the end cap set and work with one at a time. This also applies to fancier end fittings.

1 Follow the steps as for the flat end crimps (see left), but this time, insert the end of the braid into the hole of the end cap. If using round end caps, as here, use a twisting motion and ensure the right side of the braid is flush against the metal cap with no gaps. You may need to use a pointed tool to press the braid in place to achieve a neat finish.

2 Whatever type of fittings are used, no glue or raw thread ends should be visible.

STARTING AND FINISHING 27

Finishing with a tassel

Making a tassel is a beautiful way to finish a kumihimo braid. It can be used with bookmarks, bag pulls, keyrings or jewellery and can become the real feature of the project.

1 Remove the braid from the plate, being sure to keep a firm hold on the finish point of the braid. Lay a loop of scrap thread approx. 20cm (8in) on top of the braid, as shown with the red loop.

2 Using one of the braiding threads from the back of the braid (here, turquoise), whip around the base of the braid and the scrap thread several times while holding it all firmly. The whipping should be done upwards over the end of the braid.

3 Tuck the tail of the whipping thread into the loop of the scrap piece.

4 Pull the two tails of the scrap piece so that it pulls the turquoise thread through the whipping. Discard the scrap piece. Steam the tassel and trim.

Finishing with a beaded tassel

The addition of beads to the tassel gives another dimension to the project. The beads can be added to all the threads in the tassel or to just some. Make the tassel as described above, but don't trim it until all the beads have been added.

1 Using either the end of the thread stiffened with nail varnish, or a beading needle and leader thread (see page 19), slide the required number of beads onto each thread of the tassel.

2 Once the thread is beaded, tie off with an overhand knot at the last bead added (see page 18). Use a needle to guide the knot up to the last bead. Repeat this process on as many of the threads as required. Steam and trim the tassel.

Projects

This chapter features step-by-step instructions for 50 flat kumihimo braids, from simple friendship bracelets and woven chevron patterns to the more complex zigzag designs. At the end is a whole section devoted to adding beads to the different braiding patterns. Each project lists the skill level required.

You will need

50cm (20in) lengths of 2mm nylon braiding cord:

- **Bracelet 1:**
 3 lengths of Light Blue and 3 lengths of Dark Blue

- **Bracelet 2:**
 2 lengths of Light Blue and 4 lengths of Dark Blue

- **Bracelet 3:**
 6 lengths of Light Blue

My First Friendship Bracelets

These little bracelets are fun to make, and all your friends are sure to want one. They are ideal for your first braid, and once you have the moves memorised, it's easy to make variations by changing the position and colours of the threads.

Technique

The braid has thread in six positions. It is started with two knots and finished with a third knot. The space between the first two knots forms a fastening loop for the third knot to pass through when wearing.

Preparing the plate and threads

Tie the six lengths of thread together at one end with an overhand knot (see page 18). Tie a second knot, leaving a space of approx. 2cm (¾in), to create the fastening loop. Place the knots in the hole of the plate and position the threads in the slots as shown in step 1. Each warp will be approx. 38cm (15in) long.

Be a better braider

SKILL LEVEL 1

- The length of each warp for this braid should be double the finished length of the project. For example, to make a 60cm (24in) necklace, each warp should be 120cm (48in) long.

- To achieve the correct spacing when tying the second knot at the start of the braid, wrap the threads around a pencil.

- Lost your way? The last thread moved will be on top of the others at the point of braiding. If taking a break, it is best to stop after a step 4 so you can restart a repeat at step 3.

- **Front & back:** The front faces away from the braider. It is slightly rounded compared to the back, but there is virtually no difference.

Bracelet 1

1 Place Light Blue in slots 5, 6 and 7, and Dark Blue in ⑤, ⑥ and ⑦.

2 Move 5 over to B and ⑤ over to Ⓑ.

3 Move ⑥ up to 5, 6 down to ⑥, ⑦ up to 6 and 7 down to ⑦.

4. Move Ⓑ up to 7, B over to Ⓑ and 5 down to B.

5. The plate will now look like this. Repeat steps 3–4 for 16.5cm (6½in) or length required. The colours swap sides after each round. On the final repeat of step 4, move Ⓑ up to 7 and B down to ⑤.

Bracelet 2
Set up the plate by placing Light Blue in slots 5 and 7, and Dark Blue in 6, ⑤, ⑥ and ⑦. Follow the braiding instructions for Bracelet 1.

Bracelet 3
Set up the plate by placing Light Blue in all six positions and braid as instructed for Bracelet 1.

Finishing
Remove the braid from the plate and tie the end with an overhand knot. Trim each end, leaving tassels approx. 3cm (1¼in) long. To wear, insert the knot at the finish end through the middle of the threads in the knotted starting loop.

Finished size: The braid is about 16.5cm (6½in) long and 8mm (5/16in) wide.

PROJECTS

You will need

Six 150cm (60in) lengths of 0.8mm nylon braiding cord in Variegated Neon for each lace

6 small E-Z Bobs

Alternative thread: Embroidery thread, but remember that the finished braid needs to fit through the eyelets in the shoe

Funky Sneaker Laces

The braid used for these fun sneaker laces is quick and easy to make, and therefore ideal for a beginner. Using variegated neon thread means you can make a bright multicoloured braid without having to handle several different colours.

Technique
The braid has threads in six positions and is started and finished with a knotted tassel.

Preparing the plate and threads
Tie the six lengths of thread together with an overhand knot (see page 18) approx. 7.5cm (3in) from one end. Place the knotted end of the threads in the hole of the plate and position the threads in the slots as shown in step 1. Each warp will be approx. 144cm (57in) long. Wind all the threads on to bobbins.

Be a better braider

SKILL LEVEL 1

- The starting length of each thread is twice the finished length of the lace.
- If you don't have any bobbins, tie the long threads in little bundles to prevent tangles.
- Make short versions to use as little bracelets or anklets.
- **Front & back:** The front faces away from the braider. It has an evident 'V' pattern, while the back looks more woven.

Front Back

1 Place the threads in slots 5, 6, 7, 8, ⑥ and ⑦.

2 Move 6 over to Ⓑ and 7 over to B.

3 Move ⑥ up to 6 and 5 down to ⑥.

Finishing
Remove the braid from the plate and tie the end with an overhand knot. Trim each end, leaving tassels about 5cm (2in) long.

Finished size: The braid is about 75cm (30in) long and 4mm (3/16in) wide.

4 Move ⑦ up to 7 and 8 down to ⑦.

5 Move Ⓑ up to 8 and B up to 5.

6 The plate will now look like this. Repeat steps 2–5 for 75cm (30in) or length required.

PROJECTS

You will need

100cm (40in) lengths of 1mm nylon braiding cord:

- **Bracelet 1:**
 1 length each of Lime, Bright Pink, Pink and Lilac

- **Bracelet 2:**
 4 lengths of Bright Pink

- **Bracelet 3:**
 4 lengths of Pink

Alternative thread:
1mm rattail or satin cord

Tutti-Frutti Bracelets

These little bracelets are quick and fun to make. The multicoloured version is shown in the instructions, but try making the braid in just one colour for a more formal look, or use a luscious silk thread instead. All three bracelets are made with the same pattern, so you can see how versatile it is.

Technique
The braid has thread in eight positions. It is started with a plaited loop and finished with a knot and plaited tails to form the closure.

Preparing the plate and threads
Make a plaited loop at the midpoint of the threads (see page 24) and place the loop in the hole of the plate. It is important to keep a firm hold of the loop while setting up the plate, and for the first few moves, to prevent the loop from collapsing. Position the threads in the slots as shown in step 1. Each warp will be approx. 48cm (19in) long.

Be a better braider

SKILL LEVEL 1

- The length of each warp for this braid should be double the finished length of the project. For example, to make a 60cm (24in) necklace, each warp should be 120cm (48in) long.
- Use just two colours for a different effect.
- **Front & back:** The front faces away from the braider and has a distinct pattern of 'V's.

Front Back

1 Place Bright Pink in slots 6 and 7, Lime in 5 and 8, Pink in ⑥ and ⑦ and Lilac in ⑤ and ⑧.

2 Move 6 over to Ⓑ and 7 over to B.

3 Left side: Move ⑥ up to 6, 5 down to ⑥ and ⑤ up to 5. Right side: Move ⑦ up to 7, 8 down to ⑦ and ⑧ up to 8.

4 Move Ⓑ down to ⑧ and B down to ⑤.

5 The plate will now look like this. Repeat steps 2–4 for 16.5cm (6½in) or length required. The colours return to the starting position after every fourth round.

Finishing
Remove the braid from the plate and tie the end with a double overhand knot (see page 25). Divide the remaining threads into two sections and plait each for 4cm (1½in). Tie an overhand knot at each end, then trim. To wear, insert the double knot through the plaited loop. Twist each plaited tail around and through the loop again to secure.

Finished size: The braid is about 16.5cm (6½in) long and 8mm (5/16in) wide.

PROJECTS

You will need

100cm (40in) lengths of 2mm nylon braiding cord:
- 2 lengths of Orange
- 2 lengths of Goldenrod

Alternative thread:
Imposter/Biron kumihimo thread in #50 Orange and #4 Goldenrod

Orange Sherbet Bracelet

Both sides of this braid are beautiful and interesting, so you can wear it with either side as the front, or you could make two and wear one each way to show the different patterns that are highlighted by the two colours. This is also a fabulous braid for thicker threads.

Technique
The braid has thread in eight positions. It is started with a knotted loop and finished with a knot and plaited tails to form the closure.

Preparing the plate and threads
Make a knotted loop at the midpoint of the threads by folding the threads in half and tying them together with an overhand knot (see page 18) no more than 2.5cm (1in) from the fold. Place the loop in the hole of the plate and position the threads in the slots as shown in step 1. Each warp will be approx. 38cm (15in) long.

Be a better braider
SKILL LEVEL 1

- When tying the knot to form the loop closure, wrap the threads around something that is thick enough to give the size required.
- Add a decorative bead before tying the finish knot.
- **Front & back:** The front faces towards the braider and has a raised texture. The black is flatter, with two distinct rows of 'V's.

Front | Back

1 Place Goldenrod in slots 5, 6, 7 and 8, and Orange in ⑤, ⑥, ⑦ and ⑧.

2 Move ⑧ over to B and ⑤ over to Ⓑ.

3 Move 6 down to ⑤, ⑥ up to 6 and 5 down to ⑥.

4 Move 7 down to ⑧, ⑦ up to 7 and 8 down to ⑦.

5 Move Ⓑ up to 8 and B up to 5. Repeat steps 2–5 for 16.5cm (6½in) or length required. The colours return to the starting position after every second round.

Finishing
Remove the braid from the plate, divide the remaining threads into two sections, with the colours distributed evenly. Plait each section for 4cm (1½in). Tie an overhand knot at each end, then trim. To wear, insert the plaited tails through the starting loop. Bring the ends of the tails around the loop and then through the space between the tails and the loop to secure.

Finished size: The braid is about 16.5cm (6½in) long and 8mm (5/16in) wide.

PROJECTS

You will need

100cm (40in) lengths of 2mm rattail or satin cord:

4 lengths of Lavender

4 lengths of Purple

End caps with 4 x 10mm hole and clasp

Alternative thread: Imposter/Biron kumihimo thread

Pansy Eyes Necklace

This is a fabulous chunky necklace, with the colours separating at intervals to form the 'eyes' of the pansy, then joining again for the main braid. Both sides are interestingly different. This braid lends itself to thicker threads, such as the rattail used here.

Technique

The braid has thread in eight positions. It is started with a knot and finished with end caps. The main section of the braid is worked using the same sequence of moves as the Orange Sherbet Bracelet. The 'eye' section starts with the moves to the side slots – B and Ⓑ – but this time the threads stay on the same side of the plate rather than crossing over each other.

Preparing the plate and threads

Tie the eight lengths of thread together at one end with an overhand knot (see page 18). Place the knotted end of the threads in the hole of the plate and position the threads in the slots as shown in step 1. Each warp will be approx. 100cm (40in) long.

Be a better braider

SKILL LEVEL 2

- Vary the size of the 'eye' to make your braid unique.
- When removing the braid from the plate, quickly tie it with an overhand knot to prevent it from coming undone while deciding on the finish.
- **Front & back:** The front faces towards the braider and has a raised texture. The back is flatter, with two rows of 'V's.

Front **Back**

1 Place Lavender in slots 5, 6, Ⓢ and Ⓑ, and Purple in 7, 8, Ⓟ and Ⓑ.

2 Section A (main braid): Repeat steps 2–5 of Orange Sherbet (see page 36) eight times in total.

3 Section B (eye of the braid): *Move Ⓑ over to Ⓑ and Ⓢ over to B (see left). This is the move that separates the braid into two. Work steps 3–5 of Orange Sherbet once.** Repeat from * to ** seven more times (making eight in total). This creates two separate braids. These will be joined again when another section A is worked.

4 Continue braiding, alternating sections A and B for approx. 60cm (24in), finishing with a section A to match the start of the necklace.

Finishing
See page 26 for instructions on how to finish the braid with end caps.
Finished size: The braid is about 60cm (24in) long and 12mm (½in) wide.

PROJECTS

You will need

1mm rattail or satin cord:

- **Bracelet:**
 Two 100cm (40in) lengths of Dark Green and two of Light Green

- **Necklace:**
 Two 200cm (80in) lengths of Dark Green and two of Light Green

- **For necklace only:**
 10mm flat end crimps and clasp

 Pendant (optional)

Peppermint Leaves Ensemble

This pretty little braid is worked in two colours to show off the pattern. The side with the chevrons is used as the front here, but both sides look good.

Technique
The braid has thread in eight positions. The bracelet is started with a plaited loop and finished with a knotted tassel. The necklace is started with a neat end and finished with end crimps.

Preparing the plate and threads
- **Bracelet:** Make a plaited loop at the midpoint of the threads (see page 24) and place the loop in the hole of the plate. It is important to keep a firm hold of the loop while setting up the plate, and for the first few moves, to prevent the loop from collapsing.
- **Necklace:** Using a scrap piece of thread, tie all the threads together at the centre with a lark's head knot to form a neat end (see page 23) and place the tie in the hole of the plate.
- **Both:** Position the threads in the slots as shown in step 1. Each necklace warp will be approx. 100cm (40in) long, each bracelet warp 48cm (19in) long.

Be a better braider

SKILL LEVEL 2

- If the braid will not stay in the hole of the plate, ease it back into place when re-tensioning the top threads (see page 17).
- Make the plaited loop of the bracelet to fit a decorative bead instead of a double knot.
- **Front & back:** The front faces towards the braider. It is slightly textured with a 'V' pattern; the back has straighter stripes.

Front Back

1 Place Light Green in slots 5, 6, 7 and 8, and Dark Green in ⑤, ⑥, ⑦ and ⑧.

2 Move 5 and 6 one space left to 4 and 5. Move 7 and 8 one space right to 8 and 9.

3 Move ⑥ up to 6, ⑦ up to 7, 5 down to ⑥, 8 down to ⑦, ⑤ up to 5 and ⑧ up to 8.

6 Repeat steps 2–5 for 16.5cm (6½in) for bracelet, 56cm (22in) for necklace or length required for either. The colours return to the starting position after every second round.

Finishing

Bracelet: Remove the braid from the plate and tie the end with a double overhand knot (see page 25). Trim to leave a 6.5cm (2½in) tassel. To wear, insert the double knot and tassel through the starting loop.

Necklace: See page 26 for how to finish the braid with end crimps. The pendant will probably have to be fitted before you attach the second crimp.

Finished size: The bracelet braid is about 16.5cm (6½in) long, the necklace 56cm (22in) long. Both are 8mm (5/16in) wide.

4 Move ⑥ over to ⑤ and ⑦ over to ⑧.

5 Move 4 down to ⑦ and 9 down to ⑥. Note how the threads are now crossed over each other.

PROJECTS

Blue Ice Bracelet

This braid features a distinct chevron pattern that shows up clearly when worked in two colours. By using a 2mm cord to make the bracelet, the result is quite chunky. Make it using 1mm rattail or satin cord for a finer and flatter braid.

You will need

100cm (40in) lengths of 2mm nylon braiding cord:

3 lengths of Dark Blue

2 lengths of Light Blue

Alternative thread: 2mm rattail or satin cord

Technique
The braid has thread in 10 positions. It is started with a plaited loop and finished with a knot and plaited tails to form the closure.

Preparing the plate and threads
Make a plaited loop at the midpoint of the threads (see page 24) and place the loop in the hole of the plate. It is important to keep a firm hold of the loop while setting up the plate, and for the first few moves, to prevent the loop from collapsing. Position the threads in the slots as shown in step 1. Each warp will be approx. 48cm (19in) long.

Be a better braider

SKILL LEVEL 1

- Try changing the threads at 4 and 9 to a third colour and see the difference.
- This length of thread will make a braid 25cm (10in) long if you omit the starting loop and braided tails.
- **Front & back:** The front faces away from the braider. It has a pattern of two light 'V's alternating with three dark 'V's.

Front Back

1 Place Light Blue in slots 6, 7, ⑥ and ⑦, and Dark Blue in 4, 5, 8, 9, ⑤ and ⑧.

2 Move 6 over to ⑧ and 7 over to B.

3 Left side: Move ⑥ up to 6, 5 down to ⑥, ⑤ up to 5 and 4 down to ⑤.

4 Right side: Move ⑦ up to 7, 8 down to ⑦, ⑧ up to 8 and 9 down to ⑧.

5 Move B up to 4 and ⑧ up to 9. Repeat steps 2–5 for 18cm (7in) or length required. The colours return to the starting position after every fifth round.

Finishing
Remove the braid from the plate and tie the end with an overhand knot (see page 18). Divide the remaining threads into two sections and braid each for 4cm (1½in). Tie an overhand knot at each end, then trim. To wear, insert the knot through the plaited loop. Twist each plaited tail around and through the loop again to secure.

Finished size: The braid is about 18cm (7in) long and 12mm (½in) wide.

44 PROJECTS

You will need

1mm rattail or satin cord:

Three 100cm (40in) lengths of Lime

One 100cm (40in) length of Turquoise

One 112cm (44in) length of Turquoise

Note: The longer thread is for whipping around the loop at the starting end of the braid

Cool Green Bookmark

This is a woven braid, traditionally called anda-gumi. It is a very flat braid that could easily become a bracelet instead of a bookmark. By using these cool colours, the result is a soft geometrical pattern, but it would be more pronounced if contrasting colours were used. The rattail gives the braid a beautiful sheen.

Technique
The braid has thread in 10 positions. It is started with a plaited loop and finished with a tassel.

Preparing the plate and threads
Make a plaited loop at the midpoint of the threads (see page 24), positioning the threads so that the extra length of the longer Turquoise thread is at the back of the plate. Use the longer Turquoise thread to whip around the base of the loop. Once this is done, all the threads should be the same length. Place the loop in the hole of the plate and, keeping a firm hold of the whipping, position the threads in the slots as shown in step 1. Each warp will be approx. 48cm (19in) long.

Be a better braider

SKILL LEVEL 1

- At step 4, move B straight over to Ⓑ so that you complete the first move of step 2 in one go and then continue from there.
- If you make a mistake, undo the braid by reading the steps in reverse, fix the problem and then continue.
- **Front & back:** The front faces away from the braider. It is slightly smoother with a clearer pattern.

Front Back

1 Place Lime in slots 4, 6, 8, ④, ⑥ and ⑧, and Turquoise in 5, 7, ⑤ and ⑦.

2 Move 4 over to B and ④ over to Ⓑ.

3 Left side: Move ⑤ up to 4, 5 down to ⑤, ⑥ up to 5 and 6 down to ⑥. Right side: Move ⑦ up to 6, 7 down to ⑦, ⑧ up to 7 and 8 down to ⑧.

4 Move Ⓑ up to 8 and B down to ④. (Refer to 'Be a better braider' for a tip with this last move when working a repeat.)

5 The plate will now look like this. Repeat steps 2–4 for 18cm (7in) or length required. The colours return to the starting position after every 10th round.

Finishing
Remove the braid from the plate. Using one of the Turquoise threads, whip around the finish end to form a tassel (see page 27). Trim the tassel to 9cm (3½in).

Finished size: The braid is about 18cm (7in) long and 12mm (½in) wide.

Strawberry Kisses Lariat

You will need

2.7m (105in) long sections of Imposter/Biron kumihimo thread:

3 sections of #19 Wine

1 section of #38 Ivory

1 section of #16 Pink

10 small E-Z Bobs

Alternative thread: Silk embroidery thread, rattail or satin cord, but note that the appearance of thick/thin threads will not be as pronounced

What an interesting braid this is! It has a diagonal stripe of the lighter colours worked into it, and the structure of the braid appears as though the threads are of different thicknesses even though they are in fact all the same. Both sides of the braid look good, so you can use either side as the front.

Technique

The braid has thread in 10 positions. It is started with a neat end and finished with a knotted tassel.

Preparing the plate and threads

Position the threads evenly across the hole in the plate as follows:
- **Pink:** 4 across to ④
- **Wine:** 5 across to ⑤, 6 across to ⑥ and 7 across to ⑦
- **Ivory:** 8 across to ⑧

Using a scrap piece of thread, tie the threads together at the hole in the plate with a lark's head knot to form a neat end (see page 23). Each warp will be 135cm (52½in) long. Wind all the threads on to bobbins.

Be a better braider

SKILL LEVEL 2

- Traditional kumihimo threads come in a rope of four sections (see page 13).
- Use the full length of the thread. It is better for the braid to be too long rather than too short.
- **Front & back:** The front faces towards the braider. It is textured and appears to have threads of different thicknesses. The back is flat with uniform stripes.

Front **Back**

1 Set up the plate as per the diagram, tied together at the centre with a lark's head knot.

2 Move 4 over to Ⓒ and 4 over to Ⓑ.

3 Left side: Move ⑤ up to 4, 5 down to ④, ⑥ up to 5 and 6 down to ⑤. Right side: Move ⑦ up to 6, 7 down ⑥, ⑧ up to 7 and 8 down to ⑦.

Finishing

Remove the braid from the plate and tie the end with an overhand knot (see page 18). Trim to leave a tassel 7.5cm (3in) long. Stitch the starting end to the back of the finish end, checking first that the braid will go over your head.

Finished size: The braid is about 66cm (26in) long and 10mm (3/8in) wide.

4 Move Ⓑ up to 8 and Ⓒ down to ⑧. Repeat steps 2–4 for 66cm (26in) or length required. It must be long enough to fit over the head once the ends are sewn together.

Grapevine Choker

Picture purple grapes on the green vine. The two shades of purple thread form ridges over the green, and the natural twist of the braid makes it quite unique. The choker is finished with a rhinestone clasp that can be worn at the front or back.

Technique
The braid has thread in 10 positions. It is started with a neat end and finished with end caps. The top and bottom threads swap places each time they are moved, as do the side threads.

Preparing the plate and threads
Position the threads evenly across the hole in the plate as follows:
- **Lime:** B across to Ⓑ
- **Eggplant:** 5 across to ⑤ and 6 across to ⑥
- **Lavender:** 7 across to ⑦ and 8 across to ⑧

Using a scrap piece of thread, tie the threads together at the hole in the plate with a lark's head knot to form a neat end (see page 23). Reposition the top and bottom threads with Eggplant at the top and Lavender at the bottom as shown in step 1. Each warp will be 135cm (52½in) long. Wind all the threads on to bobbins.

You will need
2.7m (105in) long sections of Imposter/Biron kumihimo thread:
- 1 section of #9 Lime
- 2 sections of #10 Eggplant
- 2 sections of #51 Lavender

End caps with 6mm hole and clasp

8 small E-Z Bobs

Alternative thread: Kumihimo fine silk thread, rattail or satin cord

Be a better braider
SKILL LEVEL 2

- After moving the Lime threads in step 5, tension them so the purple threads come together at the point of braiding.
- The Lime thread is used up almost twice as fast as the Eggplant and Lavender. When my Lime was finished, there was approx. 60cm (24in) left on each of the purple bobbins, so to make a longer necklace, only the Lime needs to be longer.
- Tie a knot in the end of the leftover purple threads before cutting for use in another braid. Store the threads on bobbins to prevent tangles.
- **Front & back:** There is no difference between the two sides of this braid.

1 Set up the plate as per the diagram, tied together at the centre with a lark's head knot.

2 Swap the sides: Move B over to Ⓑ and Ⓑ over to B. It is important that the thread from the right passes to the top of the one from the left.

3 Move each thread at the bottom one space to the right to make space for the next sequence.

4 **Left side:** Move 5 down to ⑤, ⑥ up to 5, 6 down to ⑥ and ⑦ up to 6. **Right side:** Move 7 down to ⑦, ⑧ up to 7, 8 down to ⑧ and ⑨ up to 8.

5 **Swap the sides:** Move ⑧ over to B and B over to ⑧; tension the threads (see 'Be a better braider', tip 1). Repeat steps 3–5 until the braid is 45cm (18in) or until all the Lime thread is used up.

Finishing
See page 26 for instructions on how to finish the braid with end caps, referring also to tip 3 in 'Be a better braider'.

Finished size: The braid is about 45cm (18in) long and 10mm (3/8in) wide.

Golden Dreams Necklace

This braid features a chevron pattern in beautiful golden colours. The structure of the braid is very flat, so it would also be ideal as a bracelet.

Technique
The braid has thread in 12 positions. It is started with a neat end and finished with end crimps.

Preparing the plate and threads
Position the threads evenly across the hole in the plate as follows:
- **Tangerine:** 6 across to ⑥ and 7 across to ⑦
- **Goldenrod:** 5 across to ⑤ and 8 across to ⑧
- **Ivory:** 4 across to ④ and 9 across to ⑨

Using a scrap piece of thread, tie the threads together at the hole in the plate with a lark's head knot to form a neat end (see page 23). Each warp will be 100cm (40in) long.

You will need
200cm (80in) lengths of 1mm rattail or satin cord:
- 2 lengths of Tangerine
- 2 lengths of Goldenrod
- 2 lengths of Ivory

12mm flat end crimps and clasp

Be a better braider
SKILL LEVEL 1

- Check the braid regularly to make sure that the pattern is forming correctly on the front.
- For the best result, shape the braid over steam, pulling it laterally as well as lengthways.
- **Front & back:** The front faces away from the braider. It has a clear pattern of 'V's, with a wider centre point than on the back.

Front Back

1 Set up the plate as per the diagram, tied together at the centre with a lark's head knot.

2 Move 6 over to Ⓑ and 7 over to B.

3 Left side: Move ⑥ up to 6, 5 down to ⑥, ⑤ up to 5, 4 down to ⑤ and ④ up to 4.

4 Right side: Move ⑦ up to 7, 8 down to ⑦, ⑧ up to 8, 9 down to ⑧ and ⑨ up to 9.

5 Move Ⓑ down to ⑨ and B down to ④. Repeat steps 2–5 for (56cm (22in) or length required. The colours return to the starting position after every sixth round.

Finishing
See page 26 for instructions on how to finish the braid with end crimps.

Finished size: The braid is about 56cm (22in) long and 12mm (½in) wide.

PROJECTS

You will need

2.7m (105in) long sections of Imposter/Biron kumihimo thread:

2 sections of #30 Ocean Jade

2 sections of #9 Lime

2 sections of #M25 Gold Metallic

End caps with 4 x 11mm hole and clasp

12 small E-Z Bobs

Rainforest Necklace

What a difference some metallic thread makes! By adding a gold thread, this woven braid takes on a whole new dimension, with the geometrical pattern clearly visible. The braid requires some patience but the outcome is well worth the effort. This would be a fabulous addition to a plain shirt.

Technique
The braid has thread in 12 positions. It is started with a neat end and finished with end caps.

Preparing the plate and threads
Position the threads evenly across the hole in the plate as follows:
- **Ocean Jade:** 4 across to ⑨ and 9 across to ④
- **Lime:** 5 across to ⑧ and 8 across to ⑤
- **Gold:** 6 across to ⑦ and 7 across to ⑥

Using a scrap piece of thread, tie the threads together at the hole in the plate with a lark's head knot to form a neat end (see page 23). Each warp will be 135cm (52½in) long. Wind all the threads on to bobbins.

Be a better braider
SKILL LEVEL 2

- Remember to keep hold of the tie in the hole of the plate for the first few moves until the braid structure is established.
- When doing the up/down moves of the top and bottom threads, the threads should touch each other at the point of braiding.
- Keep the threads smooth and neat (see page 13).
- Always work to the end of a round before taking a break from braiding. You can then start again from the beginning of the repeat sequence.
- **Front & back:** There is only a very slight difference between the two sides of this braid. Choose the side you like best as the front.

1 Set up the plate as per the diagram, tied together at the centre with a lark's head knot.

2 Move 4 over to B and ④ over to ⑧.

3 Left side: Move ⑤ up to 4, 5 down to ⑤, ⑥ up to 5, 6 down to ⑥ and ⑦ up to 6.
Right side: Move 7 down to ⑦, ⑧ up to 7, 8 down to ⑧, ⑨ up to 8 and 9 down to ⑨.

4 Move Ⓑ up to 9, B over to Ⓑ and 4 down to B.

5 The plate will now look like this. Repeat steps 3–4 for 70cm (28in) or length required.

Finishing
See page 26 for instructions on how to finish the braid with end caps.
Finished size: The braid is about 70cm (28in) long and 20mm (¾in) wide.

54 PROJECTS

Fairy Meadow Necklace

This really is a braid fit for a princess, in delicate shades of pink with just a hint of soft meadow green. The hand-dyed silk thread has a beautiful, lustrous sheen. Attach some slides or embellish with a brooch for a special occasion.

Technique
The braid has thread in 16 positions. It is started with a neat end and finished with end crimps.

Preparing the plate and threads
Cut each skein of thread into two equal lengths. Fold each length in half to use doubled, giving eight lengths of doubled thread in total. Position them evenly across the hole in the plate as follows:
- **Dawn:** 3, 4, 5, 8, 9, 10 across to ③, ④, ⑤, ⑧, ⑨, ⑩ in order listed
- **Meadow:** 6 across to ⑥ and 7 across to ⑦

Using a scrap piece of thread, tie the threads together at the hole in the plate with a lark's head knot to form a neat end (see page 23). Each warp will be 100cm (40in) long. Wind all the threads on to bobbins.

You will need

8m (8¾yd) skeins of Exotic Lights hand-dyed silk thread:

3 skeins of #12 Dawn (variegated pastels)

1 skein of #11 Meadow (soft green)

19mm flat end crimps and clasp

Slides or brooch for embellishment (optional)

16 small E-Z Bobs

Alternative thread: Silk thread equivalent to pearl cotton #3

Be a better braider
SKILL LEVEL 1

- If you are using a thicker thread, there is no need to fold it doubled.
- There is a small amount of stretch in this braid. Shape it over steam.
- As an alternative to end caps and clasp, stitch a beaded loop to the starting end and finish with a little beaded tassel to go through the loop as a closure.
- **Front & back:** With the type of thread used, there is little difference between the two sides of the braid. If using a coarser thread, such as rattail or satin cord, a 'V' pattern would be clear on the side facing away from the braider.

1 Set up the plate as per the diagram, tied together at the centre with a lark's head knot.

2 Move 6 over to ⑧ and 7 over to B.

3 Left side: Move ⑥ up to 6, 5 down to ⑥, ⑤ up to 5, 4 down to ⑤, ④ up to 4, 3 down to ④ and ③ up to 3.

4 Right side: Move ⑦ up to 7, 8 down to ⑦, ⑧ up to 8, 9 down to ⑧, ⑨ up to 9, 10 down to ⑨ and ⑩ up to 10.

5 Move ⑧ down to ⑩ and B down to ③. Repeat steps 2–5 for 56cm (22in) or length required.

Finishing
See page 26 for instructions on how to finish the braid with end crimps. If adding embellishments, you may need to fit them before adding the second end crimp.
Finished size: The braid is about 56cm (22in) long and 19mm (¾in) wide.

56 PROJECTS

You will need

120cm (48in) lengths of 1mm nylon braiding cord:

4 lengths of Yellow

4 lengths of Rusty Red

Alternative thread:
1mm rattail or satin cord

Red and Gold Bookmark

Rows of tiny stripes on one side and rows of 'V's forming a more intricate design on the other side make up the pattern of this beautiful braid. It would be perfect for a bookmark, bracelet or belt.

Technique
The braid has thread in 16 positions. It is started with a neat end and finished with a tassel. Another tassel at the starting end is formed after the braid is removed from the plate.

Preparing the plate and threads
Using a scrap piece of thread, tie the threads together at the centre with a lark's head knot to form a neat end (see page 23). Place the tie in the hole of the plate and position the threads in the slots as follows:
- Yellow: 3, 4, 5, 6, 7, 8, 9, 10
- Rusty Red: ③, ④, ⑤, ⑥, ⑦, ⑧, ⑨, ⑩

Note that it is easier to tie the threads together before positioning them into the slots in this instance, because of the type of thread used. Each warp will be 60cm (24in) long.

Be a better braider

SKILL LEVEL 2

- The threads should always touch each other at the point of braiding.
- To make a 90cm (36in) belt, you will need four times the length of thread used here.
- **Front & back:** Both sides are flat, and either can be used as the front. Here, the front is the side facing towards the braider, with rows of stripes. The back features a 'V' pattern.

Front Back

1 Set up the plate as per the diagram, tied together at the centre with a lark's head knot.

2 Top left: Move 3, 4, 5 and 6 one space left to 2, 3, 4 and 5. Top right: Move 7, 8, 9 and 10 one space right to 8, 9, 10 and 11.

3 Move ⑥ up to 6 and ⑦ up to 7. Note that on the repeat moves, these threads will appear crossed at the top of the plate.

Finishing

Remove the braid from the plate and make a tassel at the finish end (see page 27). At the starting end, thread some of the excess thread through the neat end and form into a tassel. Trim the tassels to 9cm (3½in).

Finished size: The braid is about 23cm (9in) long and 15mm (⅝in) wide.

4 Left side: Move 5 down to ⑥, ⑤ up to 5, 4 down to ⑤, ④ up to 4, 3 down to ④ and ③ up to 3. Right side: Move 8 down to ⑦, ⑧ up to 8, 9 down to ⑧, ⑨ up to 9, 10 down to ⑨ and ⑩ up to 10.

5 Bottom left: Move ④, ⑤ and ⑥ one space left to ③, ④ and ⑤. Bottom right: Move ⑦, ⑧ and ⑨ one space right to ⑧, ⑨ and ⑩.

6 Move 2 over and down to ⑦. Move 11 over and down to ⑥. These threads cross over each other. Repeat steps 2–6 for 23cm (9in) or length required. From now on, the threads in the centre of the plate – both top and bottom – are crossed over each other.

PROJECTS

You will need

2.75m (3yd) lengths of soft hand-dyed variegated nylon ribbon approx. 20mm (¾in) wide:

- 4 lengths of Water Lily
- 4 lengths of Dream

Note: The ribbons are similar colours, with Dream having some red and gold in it, but one colour would work just as well

End caps with 10mm hole and clasp

Alternative ribbon: Sari ribbon

Sonata Ribbon Necklace

Ribbon is a wonderful braiding medium. You will be amazed at the way the ribbons scrunch up to form the braid. There is a tiny metallic thread in this ribbon, making the necklace fantastic for day or evening.

Technique

The braid has thread in 16 positions. It is started with a neat end and finished with end caps. The ribbons used are very similar colours and are hard to differentiate in the illustrations, so follow the written instructions carefully.

Preparing the plate and threads

Position the ribbons evenly across the hole in the plate as follows:
- Water Lily: 3, 5, 7, 9 across to ③, ⑤, ⑦, ⑨ in order listed
- Dream: 4, 6, 8, 10 across to ④, ⑥, ⑧, ⑩ in order listed

Using a scrap piece of thread, tie the ribbons together at the hole in the plate with a lark's head knot to form a neat end (see page 23). Each warp will be 137cm (54in) long.

Be a better braider

SKILL LEVEL 2

- To keep the threads together at the point of braiding, pull the side threads tight – towards the centre – as they are returned to the top and bottom of the plate.
- Divide the braid into a bracelet and necklace (see page 67).
- **Front & back:** The front faces away from the braider and is slightly rounded. The back has raised rows of 'V's on each side.

Front Back

1 Set up the plate as per the diagram, tied together at the centre with a lark's head knot.

2 Move 6 over to ⑧, 7 over to B, ⑥ over to Ⓒ and ⑦ over to C.

3 Left side: Move ⑤ up to 6, 5 down to ⑥, ④ up to 5, 4 down to ⑤, ③ up to 4 and 3 down to ④.

4 Right side: Move ⑧ up to 7, 8 down to ⑦, ⑨ up to 8, 9 down to ⑧, ⑩ up to 9 and 10 down to ⑨.

5 Move Ⓑ up to 10, B up to 3, Ⓒ down to ⑩ and C down to ③. Re-tension these threads so all threads touch each other at the point of braiding. Repeat steps 2–5 for 60cm (24in) or length required.

Finishing
See page 26 for instructions on how to finish the braid with end caps.
Finished size: The braid is about 60cm (24in) long and 17mm ($^{11}/_{16}$in) wide.

PROJECTS

Jewel Cuff

A combination of thick and thin threads in jewel colours creates the beautiful diamond patterns within this braid. The slightly thicker metallic thread gives the braid a raised, textured look. Finished with a loop and a stunning Czech glass button, this is a gem of a braid to make.

Technique
The braid has thread in 16 positions. It is started with a neat end and finished with a plaited loop, tassel and button.

Preparing the plate and threads
Cut the metallic thread into two equal lengths. Position the threads evenly across the hole in the plate as follows:
- **Emerald:** 3, 4, 5, 7, 8, 9 across to ③, ④, ⑤, ⑦, ⑧, ⑨ in order listed
- **Amethyst:** 6 across to ⑥ and 10 across to ⑩

Using a scrap piece of thread, tie the threads together at the hole in the plate with a lark's head knot to form a neat end (see page 23). Each Emerald warp will be 50cm (20in) long, each Amethyst warp 66cm (26in) long.

You will need
- Six 100cm (40in) lengths of 1mm rattail or satin cord in Emerald
- One 2.7m (105in) long section of Imposter/Biron kumihimo thread in #M8 Amethyst Metallic Sparkle
- 22mm Czech glass button

Alternative thread: Replace the kumihimo thread with 2mm metallic rattail or satin cord

Be a better braider
SKILL LEVEL 2
- A section of Metallic Sparkle kumihimo thread has approx. 31 individual silk threads in it.
- Measure your wrist and deduct the length of the clasp to calculate the length required for a bracelet.
- **Front & back:** The front faces away from the braider, with the metallic threads slightly raised.

1 Set up the plate as per the diagram, tied together at the centre with a lark's head knot.

2 Move 3 down to B and ③ over to Ⓑ.

3 Left side: Move ④ up to 3, 4 down to ④, ⑤ up to 4, 5 down to ⑤, ⑥ up to 5, 6 down to ⑥ and ⑦ up to 6. Right side: Move 7 down to ⑦, ⑧ up to 7, 8 down to ⑧, ⑨ up to 8, 9 down to ⑨, ⑩ up to 9 and 10 down to ⑩.

Finishing

Remove the braid from the plate, divide the remaining threads into two sections with the colours distributed evenly, and plait each section for about 2.5cm (1in). Use the rattail to whip around both sections to create a plaited loop to fit over the button, finishing with a short tassel (see page 27). Check that the loop will fit over the button, then trim the tassel to 2.5cm (1in). Remove the scrap thread from the starting end, secure the end with beading thread and attach the button.

Finished size: The braid is about 18cm (7in) long and 20mm (¾in) wide.

4 Move Ⓑ up to 10, B over to Ⓑ and 3 down to B. Repeat steps 3–4 for 18cm (7in) or length required.

62 PROJECTS

Blue Skies Chevron Braid

Bookmark, headband or bracelet – what will you make with this colourful chevron-patterned braid? Perhaps you would prefer to make a belt. The threads will need to be double the required finished length of the project.

You will need

100cm (40in) lengths of 1mm rattail or satin cord:

4 lengths of Silver
4 lengths of Lilac
4 lengths of Light Blue
4 lengths of Dark Blue
4 lengths of Aqua

Alternative thread:
1mm nylon braiding cord

Technique
The braid has thread in 20 positions. It is started with a knot and should be worked using a weight tied to the knot (see 'Be a better braider').

Preparing the plate and threads
Tie the 20 lengths of thread together with an overhand knot (see page 18) approx. 7.5cm (3in) from one end. Place the knot in the hole of the plate and position the threads in the slots as follows:

- Silver: 2, 11, ②, ⑪
- Lilac: 3, 10, ③, ⑩
- Light Blue: 4, 9, ④, ⑨
- Dark Blue: 5, 8, ⑤, ⑧
- Aqua: 6, 7, ⑥, ⑦

Each warp will be approx. 85cm (33in) long.

Be a better braider

SKILL LEVEL 2

- Use whatever you have on hand for a weight; I used a pair of pliers weighing 85g (3oz).
- Apply some tension to the centre threads so they don't move too far apart and distort the braid.
- **Front & back:** The front faces away from the braider. It has double 'V's in each colour at the centre point of the chevron.

Front Back

1 Set up the plate as per the diagram and attach a weight to the knot.

2 Move 6 over to Ⓑ and 7 over to B.

3 Left side: Move ⑥ up to 6, 5 down to ⑥, ⑤ up to 5, 4 down to ⑤, ④ up to 4, 3 down to ④, ③ up to 3, 2 down to ③ and ② up to 2.

4 Right side: Move ⑦ up to 7, 8 down to ⑦, ⑧ up to 8, 9 down to ⑧, ⑨ up to 9, 10 down to ⑨, ⑩ up to 10, 11 down to ⑩ and ⑪ up to 11.

5 Move ⑧ down to ⑪ and B down to ②. Repeat steps 2–5 for 38cm (15in) or length required.

Finishing
Remove the braid from the plate and make a tassel at the finish end, using an end of Dark Blue rattail to whip around it (see page 27). Undo the starting knot and make a tassel at the start end. Trim both tassels to 7.5cm (3in).
Finished size: The braid is about 38cm (15in) long and 19mm (¾in) wide.

64 PROJECTS

You will need

Eight 300cm (120in) lengths of 1mm rattail or satin cord in Gold

Two 2.7m (105in) long sections of Imposter/Biron kumihimo thread in #M45 Silvery Metallic

Alternative thread: Replace metallic kumihimo thread with 2mm metallic rattail or satin cord

Sunshine Necklace

The combination of rattail and metallic threads creates a firm braid that can be sculpted to suit your taste.

Technique
The braid has thread in 20 positions. The metallic threads simply swap positions, while the rattail creates the body of the braid. It is started with a neat end and finished with a tassel.

Preparing the plate and threads
Position the threads evenly across the hole in the plate as follows:
- **Gold:** 2, 3, 4, 5, 8, 9, 10, 11 across to ②, ③, ④, ⑤, ⑧, ⑨, ⑩, ⑪ in order listed
- **Silvery:** 6 across to ⑥ and 7 across to ⑦

Using a scrap piece of thread, tie the threads together at the hole in the plate with a lark's head knot to form a neat end (see page 23). Each Gold warp will be 150cm (60in) long, each Silvery warp 135cm (52½in) long.

Be a better braider

SKILL LEVEL 2

- Each rattail warp is double the finished length of the braid.
- The threads must touch each other at the point of braiding, so re-tension the side threads every time they are moved.
- **Front & back:** The front faces towards the braider. It is concave with metallic 'V's running down the centre. The back is convex.

Front Back

1 Set up the plate as per the diagram, tied together at the centre with a lark's head knot.

2 Move 5 over to ⑧, 8 over to B, ⑤ over to Ⓒ and ⑧ over to C. Then move 6 left to 5 and 7 right to 8.

3 Move ⑥ up to 6, 5 down to ⑥, ⑦ up to 7 and 8 down to ⑦.

4 Left side: Move ④ up to 5, 4 down to ⑤, ③ up to 4, 3 down to ④, ② up to 3 and 2 down to ③. Right side: Move ⑨ up to 8, 9 down to ⑧, ⑩ up to 9, 10 down to ⑨, ⑪ up to 10 and 11 down to ⑩.

5 Move B up to 2, Ⓑ up to 11, C down to ② and Ⓒ down to ⑪. Re-tension these threads so they touch each other at the point of braiding. The colours will now be back in their original positions. Repeat steps 2–5 for 75cm (30in) or length required.

Finishing
Remove the braid from the plate and make a tassel at the finish end, using two ends of rattail to whip around it (see page 27). Trim the tassel to 9cm (3½in). Stitch the starting end to the back of the finish end, checking first that the braid will go over your head, and then sculpt the braid into a pleasing shape.
Finished size: The braid is about 75cm (30in) long and 15mm (⅝in) wide.

66 PROJECTS

You will need

2.7m (105in) long sections of Imposter/Biron kumihimo thread:

4 sections of #51 Lavender

4 sections of #62 Grape

4 sections of #M24 Silver Metallic

Two sets of end caps with 10mm hole and clasps

20 small E-Z Bobs

Alternative thread: Kumihimo fine silk, rattail or satin cord

Quilted Ensemble

This braid has a quilted structure with two colours alternating in a chequerboard pattern, and a lustrous silver thread running up the sides. It is then divided into a bracelet and necklace to complete the ensemble.

Technique

The braid has thread in 20 positions. It is started with a neat end, divided into two pieces and finished with end caps.

Preparing the plate and threads

Knot sections of Silver thread together at one end to give two 5.4m (210in) lengths. This is double the length of the other threads. Position the threads evenly across the hole in the plate as follows:

- **Lavender:** 2, 3, 4, 5 across to ⑦, ⑧, ⑨, ⑩ in order listed
- **Grape:** 8, 9, 10, 11 across to ③, ④, ⑤, ⑥ in order listed
- **Silver:** B across to Ⓒ and C across to Ⓑ (with the knots in the hole)

Using a scrap piece of thread, tie the threads together at the hole in the plate with a lark's head knot to form a neat end (see page 23). Each warp at the top and bottom will be 135cm (52½in) long, each warp at the sides 2.7m (105in) long. Wind all the threads on to bobbins.

Be a better braider

SKILL LEVEL 1

- The side threads in this braid need to be double the length of the other threads.
- When moving the side threads in step 4, make sure they are pulled tight to lock the main threads in place at the point of braiding. This determines the width of the braid.
- Periodically smooth out all the kumihimo threads, in particular the metallic threads.
- **Front & back:** There is no difference between the two sides of this braid.

1 Set up the plate as per the diagram, tied together at the centre with a lark's head knot.

2 Left side: Move ⑥ up to 6, 5 down to ⑥, ⑤ up to 5, 4 down to ⑤, ④ up to 4, 3 down to ④, ③ up to 3 and 2 down to ③.

3 Right side: Move ⑦ up to 7, 8 down to ⑦, ⑧ up to 8, 9 down to ⑧, ⑨ up to 9, 10 down to ⑨, ⑩ up to 10 and 11 down to ⑩.

4 Move Ⓑ over to A, Ⓒ over to D, B over to Ⓑ and C over to Ⓒ. Pull the side threads tight.

5 Move A to B and D to C. Move 3, 4, 5, 6 one space left to 2, 3, 4, 5. Move 7, 8, 9, 10 one space right to 8, 9, 10, 11. Repeat steps 2–5 for 75cm (30in) or length required.

Finishing
Remove the braid from the plate and whip around the finish end with strong beading thread (see page 26). The start end may require some whipping to secure the metallic thread. Trim the ends.

To divide necklace and bracelet: Whip around the braid 15cm (6in) – or bracelet length required – from one end. Leave a space of two checks and then whip around the braid again. Cut the braid between the two sets of whipping. Fit end caps to both bracelet and necklace.

Finished size: The bracelet braid is about 15cm (6in) long, the necklace 60cm (24in) long. Both are 15mm (5/8in) wide.

You will need

For each bracelet –
1mm rattail or satin cord:

Four 100cm (40in) lengths of Magenta

One 200cm (80in) length of Magenta

Four 100cm (40in) lengths of Ivory

One 200cm (80in) length of Ivory

End caps with 4 x 9mm hole and clasp

20 small E-Z Bobs

Alternative thread:
1mm nylon braiding cord

Three Quilted Variations

These bracelets have a quilted structure, with two colours alternating in various patterns. They are variations on the Quilted Ensemble (see page 66) and show how easy it is to completely change the look of a braid simply by altering the colour set-up at the start.

Technique

The braids each have thread in 20 positions. They are each started with a neat end and finished with end caps.

Preparing the plate and threads

Position the threads evenly across the hole in the plate as indicated in the instructions for the bracelet you are making, using the longer threads to go across the width of the plate into the side slots. Using a scrap piece of thread, tie the threads together at the hole in the plate with a lark's head knot to form a neat end (see page 23). Each warp at the top and bottom will be 50cm (20in) long, each warp at the sides 100cm (40in) long. Wind all the threads on to bobbins.

Bracelet 1

1 Referring also to the instructions above, position the shorter threads as follows:
- **Magenta:** 4, 5, 10, 11 across to ③, ④, ⑦, ⑧
- **Ivory:** 2, 3, 8, 9 across to ⑤, ⑥, ⑨, ⑩

Note that the thread colours at the bottom are in the opposite order from those at the top.

2 Position the longer threads (in any order) across the plate from B to Ⓒ and from C to Ⓑ. Tie all the threads together at the centre with a lark's head knot. Reposition the side threads with Magenta on the right and Ivory on the left.

3 Follow the braiding instructions for the Quilted Ensemble (see page 66) to make a braid approx. 16.5cm (6½in) long.

Be a better braider

SKILL LEVEL 1

- The length of thread specified will easily produce a longer braid of 19cm (7½in).
- Whatever thread you use for the bracelets, the side threads need to be double the length of the top and bottom threads.
- To braid a necklace in one of these designs, the length of the 16 main warps (top and bottom) needs to be double the required finished length of the necklace. Each of the four side warps should be double the length of the main warps.
- **Front & back:** There is no difference between the two sides of this braid.

Bracelet 2

Position the shorter threads as follows:
- **Magenta:** 3, 5, 9, 11 across to ③, ⑤, ⑦, ⑨
- **Ivory:** 2, 4, 8, 10 across to ④, ⑥, ⑧, ⑩

Note that the thread colours at the bottom are in the opposite order from those at the top. Continue as for steps 2–3 of Bracelet 1.

Bracelet 3

Position the shorter threads as follows:
- **Magenta:** 3, 5, 9, 11 across to ④, ⑥, ⑧, ⑩
- **Ivory:** 2, 4, 8, 10 across to ③, ⑤, ⑦, ⑨

Note that the thread colours at the bottom are in the same order as those at the top. Continue as for steps 2–3 of Bracelet 1.

Finishing

See page 26 for instructions on how to finish the braids with end caps.

Finished size: Each braid is about 16.5cm (6½in) long and 12mm (½in) wide.

PROJECTS

You will need

Four 150cm (60in) lengths of 1mm nylon braiding cord in Lavender

Alternative thread:
1mm rattail or satin cord

Rickrack Bookmark

This fabulous little braid is the first in a series of zigzag designs. Zigzag braids are so versatile and can be used as rickrack on garments, items of jewellery or as bookmarks. In fact, this project is the perfect length to mark your place in this book.

Technique
The braid has thread in eight positions. It is started with a plaited loop and finished with a tassel.

Preparing the plate and threads
Make a plaited loop at the midpoint of the threads and whip around the base of the loop (see page 24). Place the loop in the hole of the plate and, keeping a firm hold of the whipping, position the threads in the slots as shown in step 1. It is important to keep a firm hold of the whipping while setting up the plate, and for the first few moves, to prevent the loop from collapsing. Each warp will be approx. 72.5cm (29in) long.

Be a better braider

SKILL LEVEL 2

- Tie a knot in the end of the threads in slots 5 and ⑤. The knotted threads will be in slots 5 and B when you are ready to start step 5 or 9 prior to turning the plate the other way up to work the zigzag. This avoids having to count the moves before turning the plate.

- Instead of knotting the threads at 5 and ⑤, try using a different colour thread in these slots.

- **Front & back:** To achieve the zigzag shape, the plate is rotated 180 degrees at regular intervals. There is little or no difference between the two sides of zigzag braids.

1 Place the threads in slots 5, 6, 7 and 8 at the top and ⑤, ⑥, ⑦ and ⑧ at the bottom.

2 Move 5 down to B and ⑤ over to ⑧.

3 Start the zigzag: Move ⑥ up to 5, 6 down to ⑥, ⑦ up to 6, 7 down to ⑦, ⑧ up to 7 and 8 down to ⑧.

4 Move Ⓑ up to 8, B over to Ⓑ and 5 down to B. Repeat steps 3–4 six more times (making seven times in total) and then step 3 once again.

5 Move Ⓑ up to 8 and B down to ⑤ to return the threads to the starting position.

CONTINUED ON PAGE 72 ▶

72 PROJECTS

6 This is the most important step of the whole braid. Turn the plate around so the circled numbers are at the top. Move ⑧ down to Ⓑ and 8 over to B.

7 Continue the zigzag: Move 7 up to ⑧, ⑦ down to 7, 6 up to ⑦, ⑥ down to 6, 5 up to ⑥ and ⑤ down to 5.

8 Move B up to ⑤, Ⓑ over to B and ⑧ down to Ⓑ. Repeat steps 7–8 six more times (making seven times in total) and then step 7 once again.

9 Move B up to ⑤ and Ⓑ down to 8 to return the threads to the starting position.

10 Turn the plate the right way up. This completes the first round. Repeat steps 2–10 for 23cm (9in) or length required.

Finishing

Remove the braid from the plate and tie the end with an overhand knot (see page 18). Trim to leave a 10cm (4in) tassel.

Finished size: The braid is about 23cm (9in) long and 8mm ($5/16$in) wide.

PROJECTS 73

Jazzy Jewels Necklace

This stunning necklace is worked in jewel colours, but you could use metallic threads for extra pizzazz. The Dark Green threads form the points on one edge, while the Turquoise and Purple form the points on the other.

Technique
The braid has thread in 10 positions. It is started with a neat end and finished with end crimps.

Preparing the plate and threads
Position the threads evenly across the hole in the plate as follows:
- **Dark Green:** 4 across to Ⓐ
- **Medium Green:** 5 across to Ⓑ
- **Lime:** 6 across to Ⓒ
- **Purple:** 7 across to Ⓓ
- **Turquoise:** 8 across to Ⓔ

Using a scrap piece of thread, tie the threads together at the hole in the plate with a lark's head knot to form a neat end (see page 23). Each warp will be 150cm (60in) long. Wind all the threads on to bobbins.

You will need
300cm (120in) lengths of 1mm rattail or satin cord:
- 1 length of Dark Green
- 1 length of Medium Green
- 1 length of Lime
- 1 length of Purple
- 1 length of Turquoise

10mm flat end crimps and clasp

10 small E-Z Bobs

Be a better braider
SKILL LEVEL 2

- The lengths of thread need to be 2¾–3 times the finished length of braid required.
- Change direction every time the Dark Green thread is at 4 and B and you are ready to start step 5 or 9. This avoids having to count the moves before turning the plate.
- Hold the point of braiding when doing steps 5 and 9 to maintain the tension throughout.
- **Front & back:** To achieve the zigzag shape, the plate is rotated 180 degrees at regular intervals. There is little or no difference between the two sides of zigzag braids.

1 Set up the plate as per the diagram, tied together at the centre with a lark's head knot.

2 Move 4 down to B and Ⓐ over to Ⓑ.

3 Start the zigzag: Move ⑤ up to 4, 5 down to ⑤, ⑥ up to 5, 6 down to ⑥, ⑦ up to 6, 7 down to ⑦, ⑧ up to 7 and 8 down to ⑧.

CONTINUED ON PAGE 74 ▶

74 PROJECTS

4 Move Ⓑ up to 8, B over to Ⓑ and 4 down to B. Repeat steps 3–4 eight more times (making nine times in total) and then step 3 once again.

5 Move Ⓑ up to 8 and B down to ④ to return the threads to the starting position.

6 This is the most important step of the whole braid. Turn the plate around so the circled numbers are at the top. Move ⑧ over to Ⓑ and 8 over to B.

7 Continue the zigzag: Move 7 up to ⑧, ⑦ down to 7, 6 up to ⑦, ⑥ down to 6, 5 up to ⑥, ⑤ down to 5, 4 up to ⑤ and ④ down to 4.

8 Move B up to ④, Ⓑ over to B and ⑧ down to Ⓑ. Repeat steps 7–8 eight more times (making nine times in total) and then step 7 once again.

9 Move B up to ④ and Ⓑ down to 8 to return the threads to the starting position. Turn the plate the right way up. This completes the first round. Repeat steps 2–9 for 56cm (22in) or length required.

Finishing
See page 26 for instructions on how to finish the braid with end crimps.
Finished size: The braid is about 56cm (22in) long and 10mm (3/8in) wide.

Long and Short Zigzag Necklace

This unusual braid requires counting to create the pattern of alternating long and short points, but it is still fun to make.

Technique
The braid has thread in 10 positions. It is started with a plaited loop and finished with a knotted tassel. It is worked using the same sequence of moves as the Jazzy Jewels Necklace, but with a different number of repeats. The threads work up quite unevenly.

Preparing the plate and threads
Make a plaited loop at the midpoint of the threads and whip around the base of the loop (see page 24). Place the loop in the hole of the plate and, keeping a firm hold of the whipping, position the threads in the slots as follows:
- 4, 5, 6, 7, 8 across to ④, ⑤, ⑥, ⑦, ⑧ in order listed

Each warp will be approx. 147.5cm (59in) long. Wind all the threads on to bobbins.

You will need
Five 300cm (120in) lengths of 1mm rattail or satin cord in Magenta

10 small E-Z Bobs

Alternative thread: Silk or rayon embroidery thread

Be a better braider
SKILL LEVEL 3

- Always use E-Z Bobs for soft threads, particularly Imposter/Biron kumihimo threads.
- For this braid, the starting warps need to be 3 times the finished length required.
- When starting with a plaited loop, it is important to keep a firm hold of the whipping while setting up the plate and for the first few moves, to prevent the loop from collapsing.
- **Front & back:** To achieve the zigzag shape, the plate is rotated 180 degrees at regular intervals. There is little or no difference between the two sides of zigzag braids.

Making the braid
Follow the braiding instructions for the Jazzy Jewels Necklace (see page 73), but alter the number of times you work steps 3–4 and 7–8 in each round as indicated below. Steps 3–4 are worked with the plate the right way up to create the 'zig', while steps 7–8 are worked with the plate upside down to create the 'zag'. Remember that after repeating these steps the number of times stated, you should finish by working step 3 or step 7 one extra time.

- **First long end section:** Work steps 3–4 twenty times, then step 3 once more.
- **Each short point:** Work steps 7–8 four times, then step 7 once more. Work steps 3–4 four times, then step 3 once more.
- **Each long point:** Work steps 7–8 twelve times, then step 7 once more. Work steps 3–4 twelve times, then step 3 once more.
- **Last long end section:** Work steps 7–8 twenty times, then step 7 once more.

To match the sample shown, work the first end section, then starting and finishing with a short point, alternate short and long points to make 11 points in total. Finish with a long end section to match the first.

Finishing
Remove the braid from the plate and tie the end with an overhand knot (see page 18). Trim to leave a 6cm (2¼in) tassel. To wear, insert the knot and tassel through the starting loop.

Finished size: The braid is about 50cm (20in) long and 10mm (3/8in) wide.

Crazy Zigzag Necklace

This braid can be as crazy as you like – it is more of a freeform braid than the others in the zigzag series.

Technique
The braid has thread in eight positions. It is started with a neat end and finished with beads or end caps. The tips of the zigzag points are pulled during steps 3 and 7 (after each turn of the plate) to make them long and thin; note that the first point does not appear until step 7.

Preparing the plate and threads
For the extension braid (optional), follow the instructions for the Tutti-Frutti Bracelets (see page 34) to make a 25cm (10in) long braid. For the zigzag braid, divide the Silvery thread into two groups of 20 threads each (see page 13). Position the threads evenly across the hole in the plate as follows:
- **Magenta:** 3 across to ③ and 9 across to ⑨
- **Silvery:** 5 across to ⑤ and 7 across to ⑦

Using a scrap piece of thread, tie the threads together at the hole in the plate with a lark's head knot to form a neat end (see page 23). Each Magenta warp will be 150cm (60in) long, each Silvery warp 135cm (52½in) long.

You will need

Zigzag braid:
Two 300cm (120in) lengths of 1mm rattail or satin cord in Magenta

One 2.7m (105in) long section of Imposter/Biron kumihimo thread in #M45 Silvery Metallic

Extension braid:
Four 100cm (40in) lengths of 1mm rattail or satin cord in Magenta

Two beads or end cap and clasp sets with 6mm hole if adding extension braid OR one end cap set to finish without

Be a better braider
SKILL LEVEL 3

- There is no need to count with this braid. Just turn the plate when all the Magenta threads are in the top and bottom slots on the right.
- When finishing the ends with beads instead of end caps and clasps, first make sure the necklace will go over your head.
- A shorter 50cm (20in) crazy necklace would use rattail warps of 190cm (75in) and the same amount of metallic thread.
- **Front & back:** To achieve the zigzag shape, the plate is rotated 180 degrees at regular intervals. There is little or no difference between the two sides of zigzag braids.

1 Set up the plate as per the diagram, tied together at the centre with a lark's head knot.

2 Move 3 down to B and ③ over to ⑧.

3 Start the zigzag: Move ⑤ up to 3, 5 down to ⑤, ⑦ up to 5, 7 down to ⑦, ⑨ up to 7 and 9 down to ⑨. On subsequent rounds (not the first round), slightly pull the tip of the zigzag point when making these moves.

CONTINUED ON PAGE 80 ▶

Finishing

Adding extension braid: Remove each braid from the plate, whip around each finish end and trim (see page 26). Slide the two beads on to the plain braid. Stitch and glue the ends of the two braids together. When dry and secure, add more glue and slide the beads over the joins.

Finishing without extension: See page 26 for instructions on how to finish the braid with end caps.

Finished size: The zigzag braid is about 40cm (16in) long and 8mm ($5/16$in) wide. The combined necklace is 66cm (26in) long.

4 Move Ⓑ up to 9, B over to Ⓑ and 3 down to B. First round only: Repeat steps 3–4 eight more times (making nine times in total) and then step 3 once again. Note: On subsequent rounds, repeat steps 3–4 ten more times (making 11 times in total) and then step 3 once again.

5 Move Ⓑ up to 9 and B down to ③ to return the threads to the top and bottom.

6 This is the most important step of the whole braid. Turn the plate around so the circled numbers are at the top. Move ⑨ down to Ⓑ and 9 over to B.

7 Continue the zigzag: Move 7 up to ⑨, ⑦ down to 7, 5 up to ⑦, ⑤ down to 5, 3 up to ⑤ and ③ down to 3. Slightly pull the tip of the zigzag point when making these moves.

8 Move B up to ③, Ⓑ over to B and ⑨ down to Ⓑ. Repeat steps 7–8 ten more times (making 11 times in total) and then step 7 once again.

9 Move B up to ③ and Ⓑ down to 9. Turn the plate the right way up. This completes the first round. Repeat steps 2–9 for 40cm (16in) or length required.

PROJECTS **81**

Flame Interlaced Necklace

Make one braid and you will have an unusual piece of jewellery. Interlace two braids together and the result is spectacular.

You will need

1mm rattail or satin cord (per braid):

- Two 300cm (120in) lengths of Red
- Two 300cm (120in) lengths of Yellow
- One 300cm (120in) length of Goldenrod
- One 200cm (80in) length of Goldenrod

End caps with 10mm hole and clasp for interlaced braid OR 12mm flat end crimps and clasp for single braid

12 small E-Z Bobs

Technique

The braids are identical and have thread in 12 positions. They are started with a neat end and finished with end caps. This project lets the colour do the work for you – when either Red or Yellow threads are all on the right, the plate is turned the other way up.

Preparing the plate and threads

Position the threads evenly across the hole in the plate as follows:
- Red: 4 across to ④ and 9 across to ⑨
- Goldenrod: 5 across to ⑤ (long thread) and 8 across to ⑧ (short)
- Yellow: 6 across to ⑥ and 7 across to ⑦

Using a scrap piece of thread, tie the threads together at the hole in the plate with a lark's head knot to form a neat end (see page 23). For the longer threads, each warp will be 150cm (60in) long. Wind all the threads on to bobbins.

Be a better braider

SKILL LEVEL 2

- Change direction when either the Red or Yellow threads are all on the right and starting to form a point.
- The threads in slot 8 never become the weft and so can be up to 50cm (20in) shorter than the other threads.
- Bobbins are recommended here, and are essential if using thread other than rattail or braiding cord in order to avoid tangles.
- **Front & back:** To achieve the zigzag shape, the plate is rotated 180 degrees at regular intervals. There is little or no difference between the two sides of zigzag braids.

1 Set up the plate as per the diagram, tied together at the centre with a lark's head knot.

2 Move 4 down to B and ④ over to ⓑ.

3 Start the zigzag: Move ⑤ up to 4, 5 down to ⑤, ⑥ up to 5, 6 down to ⑥, ⑦ up to 6, 7 down to ⑦, ⑧ up to 7, 8 down to ⑧, ⑨ up to 8 and 9 down to ⑨.

CONTINUED ON PAGE 82 ▶

82 PROJECTS

4 Move Ⓑ up to 9, B over to Ⓑ and 4 down to B. First round only: Repeat steps 3–4 five more times (making six times in total) and then step 3 once again. Note: On subsequent rounds, repeat steps 3–4 eight more times (making nine times in total) and then step 3 once again.

5 Move Ⓑ up to 9 and B down to ④ to return the threads to the top and bottom of the plate.

6 This is the most important step of the whole braid. Turn the plate around so the circled numbers are at the top. Move ⑨ down to Ⓑ and 9 over to B.

7 Continue the zigzag: Move 8 up to ⑨, ⑧ down to 8, 7 up to ⑧, ⑦ down to 7, 6 up to ⑦, ⑥ down to 6, 5 up to ⑥, ⑤ down to 5, 4 up to ⑤ and ④ down to 4.

8 Move B up to ④, Ⓑ over to B and ⑨ down to Ⓑ. Repeat steps 7–8 eight more times (making nine times in total) and then step 7 once again.

9 Move B up to ④ and Ⓑ down to 9. Turn the plate the right way up. This completes the first round. Repeat steps 2–9 for 55cm (22in) or length required.

Finishing

Interlaced necklace: Remove each braid from the plate and, starting from the neat ends, weave the two braids together so that the zigzags interlock. If necessary, stitch one braid behind the other and fit the first end cap (see page 26) before weaving together. Stitch at the finish end, if necessary, and fit the second end cap. Shape the necklace.

Finishing as single necklace: Finish the braid with end crimps (see page 26).

Finished size: The interlaced braid is about 55cm (22in) long and 42mm (1 5/8in) wide to the tip of the points.

You will need

Two 3.5m (4yd) lengths of 2mm rattail or satin cord in Royal Blue

Two 2.7m (105in) long sections of Imposter/Biron kumihimo thread in #M45 Silvery Metallic

End caps with 4 x 11mm hole and clasp

12 small E-Z bobs

Alternative thread: Any kumihimo threads

Chequerboard Choker

This fabulous braid is worked so the main colour forms the points on either side of a woven braid. The project is worked in just two colours, but could be fun using four different colours in place of the metallic.

Technique
The braid has thread in 12 positions. It is started with a neat end and finished with end caps. It is worked using the same sequence of moves as the Flame Interlaced Necklace, but to achieve the zigzag only on the edge, the plate is rotated at shorter intervals.

Preparing the plate and threads
Cut each section of Silvery thread in half to give four 135cm (52½in) lengths. Position the threads evenly across the hole in the plate as follows:
- Royal Blue: 4 across to ④ and 5 across to ⑤
- Silvery: 6, 7, 8, 9 across to ⑥, ⑦, ⑧, ⑨ in order listed

Using a scrap piece of thread, tie the threads together at the hole in the plate with a lark's head knot to form a neat end (see page 23). Each Royal Blue warp will be 175cm (72in) long, each Silvery warp 67cm (26¼in) long. Wind all the threads on to bobbins.

Be a better braider

SKILL LEVEL 3

- Change direction every time the Royal Blue threads are all on the right-hand side of the plate when ready to do step 5 or 9.
- Use either the 'B' or 'C' slots for the side threads. Choose the ones that keep your braid straight at the point of braiding.
- The starting length for the metallic threads is double the finished length of braid required. The rattail is used up quicker than the metallic, so it needs to be 2½ times longer.
- **Front & back:** To achieve the zigzag shape, the plate is rotated 180 degrees at regular intervals. There is little or no difference between the two sides of zigzag braids.

1 Set up the plate as per the diagram, tied together at the centre with a lark's head knot.

2 Follow the braiding instructions for the Flame Interlaced Necklace (see page 81), but alter the number of repeats of steps 3–4 and 7–8 in each round as follows:
- **Steps 3–4:** Work these steps three times in total and then step 3 once again.
- **Steps 7–8:** Work these steps three times in total and then step 7 once again.

3 After completing each round, all the threads will be back in the starting position. Continue braiding for 38cm (15in) or length required.

Finishing
See page 26 for instructions on how to finish the braid with end caps. Note that this is a choker and should be worn around the neck/throat.

Finished size: The braid is about 38cm (15in) long and 35mm (1⅜in) wide to tip of points.

Lacy Wired Necklaces

The combination of thread and wire gives these two braids a beautiful woven texture. The wire becomes a delicate woven lace and allows you to mould the necklaces.

Be a better braider

SKILL LEVEL 2

- Keep the wire and thread free from tangles by regularly running them through your fingers.
- Don't let the wire get any kinks in it. Keep it as smooth as possible.
- When working with wire, glue the ends, allow it to set and then glue again to fit the end caps or crimps.
- **Front & back:** There is no difference between the two sides of these braids.

You will need

- **Zigzag necklace:**
Two 4m (13ft) lengths of 1mm rattail or satin cord in Mid Green

Four 300cm (120in) lengths of 28-gauge (0.32mm) round wire in Turquoise

End caps with 6mm hole and clasp

12 small E-Z Bobs

- **Straight necklace:**
Two 200cm (80in) lengths of 1mm nylon braiding cord in Purple

Three 200cm (80in) lengths of 30-gauge (0.26mm) round wire in Magenta

10mm flat end crimps and clasp

Technique

The zigzag braid has thread in four positions and wire in eight positions. The straight braid has thread in four positions and wire in six positions. Each is started with a neat end and finished with end caps or crimps. Both follow the sequences of moves in previous projects.

Preparing the plate and threads

For each braid, position the threads and wire evenly across the hole in the plate as described in step 1. Using a scrap piece of thread, tie the threads and wire together at the hole in the plate with a lark's head knot to form a neat end (see page 23).
- **Zigzag braid:** Each rattail warp will be 200cm (80in) long, each wire warp 150cm (60in) long. Wind all the threads and wire on to bobbins.
- **Straight braid:** Each warp will be 100cm (40in) long.

Zigzag braid

1 Referring also to the instructions above, position the threads and wire as follows:
- **Thread:** 4 across to ④ and 5 across to ⑤
- **Wire:** 6, 7, 8, 9 across to ⑥, ⑦, ⑧, ⑨

2 Follow the braiding instructions for the Flame Interlaced Necklace (see page 81), rotating the plate when all of the Mid Green thread is on the right-hand side of the plate and is starting to form the point of the zigzag.

3 Continue braiding for 56cm (22in) or length required, working the last section to match the starting end.

Straight braid

1 Referring also to the instructions above, position the threads and wire as follows:
- **Thread:** 4 across to ④ and 5 across to ⑤
- **Wire:** 6, 7, 8 across to ⑥, ⑦, ⑧

2 Follow the braiding instructions for the Cool Green Bookmark (see page 44) to make a braid 50cm (20in) long or length required.

Finishing both necklaces

Remove each braid from the plate, twist the wire and thread together, trim and fit the end caps or crimps (see page 26). Shape the braid to give the desired appearance.
Finished size: The zigzag braid is about 56cm (22in) long and 10mm ($3/8$in) wide. The straight braid is about 50cm (20in) long and 8mm ($5/16$in) wide.

Gilded Dragonfly Ensemble

This wire braid is perfect for showing off a favourite brooch or pendant. The braid is worked in one length, and then divided into a necklace and bracelet. The dragonfly brooch, a treasured gift, is detachable.

You will need

- Ten 200cm (80in) lengths of 0.38mm (0.015in) diameter plastic-coated 7-strand stainless steel tigertail wire in Gold
- Two sets of 10mm flat end crimps and clasps
- Brooch or pendant for necklace (optional)

Be a better braider

SKILL LEVEL 2

- You may find it easier to work with a weight attached to each warp and a counterweight attached to the lark's head knot.
- To add a weight to the warps, use a heavy bead or fishing sinker in an E-Z Bob.
- Tigertail is more flexible to use than regular jewellery wire because it does not kink when making the moves.
- **Front & back:** There is no difference between the two sides of this braid.

Technique

The braid has wire in 10 positions. It is started with a neat end and finished with end crimps. The wire is used doubled, and the moves are the same as for the Blue Ice Bracelet.

Preparing the plate and threads

Using two wires per slot, position the wire evenly across the hole in the plate as follows:
- 4, 5, 6, 7, 8 across to ⑤, ⑥, ⑦, ⑧, ⑨ in order listed

Using a scrap piece of thread, tie the wires together at the hole in the plate with a lark's head knot to form a neat end (see page 23). Reposition the pair of wires from slot ⑨ up to slot 9. Each warp will be 100cm (40in) long.

1 Set up the plate as per the diagram and description above, tied together at the centre with a lark's head knot.

2 Follow the braiding instructions for the Blue Ice Bracelet (see page 42) to make a braid 70cm (28in) long or length required.

Finishing

Remove the braid from the plate and tie the end with an overhand knot (see page 18). Apply some glue below the knot, allow it to dry and then cut off the knot and excess wire. Apply more glue and attach an end crimp.

- **To divide necklace and bracelet:** Apply some glue 15cm (6in) – or bracelet length required – from the finished end. Allow to dry completely and then cut the braid into two at the glued point. Apply some more glue and attach end crimps to the two cut ends. Clamp the end crimps with flat-nose pliers, making sure no glue shows. Apply glue to the start end and attach the final end crimp. If necessary, shape the braid so it lies flat at the front of the necklace. Attach a brooch or pendant to the necklace, if desired.
- **Finished size:** The bracelet braid is about 15cm (6in) long, the necklace 55cm (22in) long. Both are 8mm (5/16in) wide.

PROJECTS

You will need

Three 200cm (80in) lengths of 1mm rattail or satin cord in Dark Green

15g size 5 triangle seed beads in Transparent Emerald AB (approx. 150 beads)

End caps with 5mm hole and clasp

6 small E-Z Bobs

Emerald Princess Necklace

The threads are woven around the triangle seed beads, forming two rows of jewels with a diamond-cut edge. The necklace is finished with a magnetic rhinestone clasp in the form of a bead.

Technique

The braid has thread in six positions, with beads on the bottom three. It is started with a neat end and finished with end caps. The beads are released one at a time during braiding.

Preparing the plate and threads

- Position the threads evenly across the hole in the plate as follows: 5 across to ⑤, 6 across to ⑥ and 7 across to ⑦
- Using a scrap piece of thread, tie the threads together at the hole in the plate with a lark's head knot to form a neat end (see page 23). Each warp will be 100cm (40in) long.
- Thread 50 beads on to each warp at ⑤, ⑥ and ⑦ (see page 19). Wind all the threads on to bobbins.

Be a better braider

SKILL LEVEL 2

- When threading beads on to rattail or braiding cord, stiffen the end of the cord with a little nail varnish to make a point.
- It is time to release the beads when there are beads in both positions – ⑥ and ⑦ – at the bottom of the plate. Alternatively, count the moves from 1 to 14, starting with the first bead released. A bead is released on the counts of 1 and 3.
- **Front & back:** The front faces away from the braider, with the beads evenly raised within the braid.

Front Back

1 Set up the plate as per the diagram and description above. Follow braiding instructions as for My First Friendship Bracelets (see page 30) to braid a 1cm (½in) section without beads. This will go into an end cap when the braid is finished.

2 Continue braiding, but now release a bead every time a beaded thread is moved from ⑥ up to 5 and from ⑦ up to 6. Allow the bead to drop down the thread as the move is made. When moving B across to Ⓑ, make sure the thread passes above the two beads. Refer also to 'Adding the beads' (opposite).

3 The following sequence of up/down moves of the top and bottom threads will lock the beads in place as follows: **BEAD** [⑥ to 5; 6 to ⑥] **BEAD** [⑦ to 6; 7 to ⑦].

4 Continue until the beaded section is 53cm (21in) long or all the beads are used up. Finish with another 1cm (½in) section without beads.

Finishing

Remove the braid from the plate and tweak the beads so they are all sitting up with a flat edge showing on the front of the necklace. Fit the end caps (see page 26).

Finished size: The braid is about 56cm (22in) long and 10mm (³⁄₈in) wide.

Adding the beads

The main diagram on the right shows a bead having just been released on both threads moved to the top of the plate. The first inset picture shows the side thread moved across from B to Ⓑ above the beads, holding them in place. The second inset picture shows the beads locked in place by the following sequence of up/down moves of the top and bottom threads. See page 20 for more on beading techniques.

1) Bead released on each beaded thread as it is moved to top of plate

2) Thread moving from left to right side of plate should go above both beads

3) Following round of up/down moves separates and locks the beads in place

92 PROJECTS

You will need

Hand-dyed silk thread:

One 15m (16½yd) skein of Ophir fine thread in #37 Uluru

One 8m (8¾yd) skein of Exotic Lights thread in #37 Uluru

15g Rizo Czech glass 2.5 x 6mm beads in Topaz/Amber (approx. 210 beads)

10mm flat end crimps and clasp

6 small E-Z Bobs

Alternative thread: Imposter/Biron kumihimo thread and matching single-ply thread for the beads

Harvest Moon Choker

This project uses thick and thin threads, with the beautiful Rizo Czech glass beads on the thin threads forming a herringbone pattern.

Technique

The braid has thread in six positions, with beads on three of them. It is started with a knot and finished with end crimps. The beads are released one at a time on alternate sides, when the beaded threads are moved up to the top of the plate. The 'A' slots are used on the sides rather than the 'B' slots.

Preparing the plate and threads

- Cut three 150cm (60in) lengths of fine thread (Ophir) and three 200cm (80in) lengths of the thicker thread (Exotic Lights). Fold the thicker threads in half to use doubled.
- Tie all the threads together at one end with an overhand knot (see page 18). Place the knot in the hole of the plate and position the threads in the slots as follows:

Fine thread: 5, 6 and ⑦
Thicker thread: 7, 8 and ⑥
Each warp will be 100cm (40in) long.

- Thread a third of the beads (approx. 70) on to each of the fine threads (see page 19). Wind all the threads on to bobbins.

Be a better braider

SKILL LEVEL 1

- Each bead is amber on one side and topaz on the other. For this project they were threaded randomly, but you could thread them all the same way if you prefer.
- To make a longer braid, divide the full skeins of thread into three. Braid a longer plain section for the back of the neck.
- The thickness of the thread for the beads is determined by the size of the hole in the beads used.
- **Front & back:** The front faces away from the braider, with the beads standing up slightly along the edge of the braid.

Front **Back**

1 Set up the plate as per the diagram and description above. Follow braiding instructions as for the Funky Sneaker Laces (see page 32) to braid a 1cm (½in) section without beads. This will go into an end crimp when the braid is finished.

2 Continue braiding, but now use the 'A' slots on the sides instead of the 'B's. Release the beads one at a time, on alternate sides. When lifting the warps at the sides – in slots A and Ⓐ – to be moved up to the top of the plate, slide a bead down against the braid in the hole. Hold the bead in place against the back of the hole with a thumbnail. Refer also to 'Adding the beads' (opposite).

3 Continue braiding for 43cm (17in) or until all the beads are used up. Braid another 1cm (½in) without beads to match the start.

Finishing

See page 26 for instructions on how to finish the braid with end crimps.

Finished size: The braid is about 45cm (18in) long and 12mm (½in) wide.

Adding the beads

The main diagram on the right shows a bead having just been released on the side thread at Ⓐ as the thread is about to be moved to the top of the plate. The inset picture shows the bead being held in place with a thumbnail as the subsequent moves are made that will secure the bead in place. See page 20 for more on beading techniques.

Bead released on side thread about to be moved to top of plate

Released bead held in place with thumbnail against back of hole in plate as subsequent moves are made

Blue Bling Bead Necklace

The moves for this braid are the same as for the Funky Sneaker Laces, but what a difference silk thread, seed beads and a bit of bling can make.

You will need

- One 15m (16½yd) skein of Ophir hand-dyed fine silk thread in #2 Water Nymphs
- 8g size 8 seed beads in S/L Sapphire AB (approx. 300 beads)
- One 9 x 44mm rhinestone tube bead with 4mm hole
- 5mm flat end crimps and clasp
- 6 small E-Z Bobs

Alternative thread: Rayon embroidery thread

Technique
The braid has thread in six positions, with beads on three of them. It is started with a neat end and finished with end crimps. The beads are released one at a time on alternate sides. The 'A' slots are used on the side rather than the 'B' slots. The tube bead is added when half the braid is completed.

Preparing the plate and threads

- Cut three 250cm (100in) lengths of thread. Position the threads evenly across the hole in the plate as follows:
 5 across to ⑥, 6 across to ⑦ and 7 across to ⑧
- Using a scrap piece of thread, tie the threads together at the hole in the plate with a lark's head knot to form a neat end (see page 23). Reposition the thread from slot ⑧ up to slot 8. Each warp will be 125cm (50in) long.
- Thread 50 beads on to each warp at 5, 6 and ⑦ for the first half of the braid (see page 19). Wind all the threads on to bobbins.

Be a better braider

SKILL LEVEL 2

- The beads are released on alternate sides. The next bead to be released will be on the side of the plate with the beaded warp. For example, when the bead to be released is at Ⓐ on the right, there will not be any beads on the warp at A on the left.
- Hold the bead in place with a thumbnail against the back of the hole in the plate.
- Use a needle and leader thread to pull all the threads through the tube bead.
- **Front & back:** The front faces towards the braider, with the beads raised above the threads. The beads are flush with the threads on the back.

Front Back

1 Set up the plate as per the diagram and description above. Follow braiding instructions as for the Funky Sneaker Laces (see page 32) to braid a 1cm (½in) section without beads. This will go into an end crimp when the braid is finished.

2 Continue braiding, but now use the 'A' slots on the sides instead of the 'B's. Release the beads one at a time, on alternate sides. When lifting the warps at the sides – in slots A and Ⓐ – to be moved up to the top positions, slide a bead down against the braid in the hole. Hold the bead in place against the back of the hole with a thumbnail. See page 20 for more on beading techniques.

3 Continue braiding until all the beads are used up, approx. 24cm (9½in). Then work a section without beads to go inside the tube bead. Remove the bobbins and threads from the plate and slide the tube bead over the plain section.

4 Position the threads back in the starting position and thread on another 50 beads as before. Wind the threads on to bobbins. Continue braiding, releasing beads as before, and finish with another 1cm (½in) without beads to match the start.

Finishing
See page 26 for instructions on how to finish the braid with end crimps.

Finished size: The braid is about 50cm (20in) long and 6mm (¼in) wide.

PROJECTS

You will need

8m (8¾yd) skeins of Exotic Lights hand-dyed silk thread:

1 skein of #27 Poppy (plain colour)

1 skein of #15 Marrakesh (variegated)

20g size 6 seed beads in S/L Red AB (approx. 360 beads)

10mm flat end crimps and clasp

8 small E-Z Bobs

Alternative thread: Pearl cotton #3

Carnival Necklace

This braid has beads on just half of the threads to create a beaded edge. Using both a plain and a variegated colour results in a gorgeous necklace that can be worn long or fashioned into a decorative knot.

Technique

The braid has threads in eight positions, with beads on four of them. It is started with a knot and finished with end crimps. The beads are released one at a time during braiding.

Preparing the plate and threads

- Cut each skein of thread into four equal lengths and tie all eight threads together at one end with an overhand knot (see page 18).
- Place the knot in the hole of the plate and position the threads in the slots as follows:
 Poppy: 5, 6, 7 and 8
 Marrakesh: ⑤, ⑥, ⑦ and ⑧
 Each warp will be approx. 2m (80in) long.
- Thread each of the Poppy threads with approx. 90 beads. Wind all the threads on to bobbins.

Be a better braider

SKILL LEVEL 2

- If you need to leave your braiding, finish the entire sequence of repeated moves so, when you return, you can restart from the beginning of the sequence.
- This braid is long enough to make two shorter necklaces, or a necklace and bracelet set.
- **Front & back:** The front faces away from the braider and has a distinct 'V' pattern.

Front Back

1 Set up the plate as per the diagram and description above. Follow braiding instructions as for the Tutti-Frutti Bracelets (see page 34) to braid a 1cm (½in) section without beads. This will go into an end crimp when the braid is finished.

2 Continue braiding, but now release a bead every time a beaded thread is moved from ⑤ up to 5 and from ⑧ up to 8. Make sure the bead tucks under the threads going from B down to ⑤ and from ⑧ down to ⑧. Refer also to 'Adding the beads'. Continue braiding until the beaded section is 100cm (40in) or length required.

3 Work another 1cm (½in) section without beads to match the start.

Adding the beads

The main diagram on the right shows a bead having just been released. The inset picture shows the side thread moved down, with the bead tucked under it, to secure the bead in place. See page 20 for more on beading techniques.

As thread is moved to top of plate, bead is released and slides down against braid

Side thread moves down and wraps around to secure bead in place

Finishing

See page 26 for instructions on how to finish the braid with end crimps. Fashion the centre of the necklace into a decorative knot if desired (see right). Because of the weight of the beads, the knot will need to be stitched into place to prevent it from falling apart.

- **Finished size:** The braid is about 60cm (24in) long and 12mm (½in) wide. The knot will take approx. a third of the length.

You will need

- Two 200cm (80in) lengths of 1mm rattail or satin cord in Purple
- Two 300cm (120in) lengths of 0.8mm nylon braiding cord in Purple
- 6g size 8 seed beads in C/L Purple Fuchsia AB (approx. 184 beads)
- 6mm flat end crimps and clasp
- Pendant (optional)
- 8 small E-Z Bobs

Royale Necklace

The beads are released to form little clusters of four beads at regular intervals along the length of this braid. The addition of a pendant adds interest and weight to the necklace.

Technique

The braid has thread in eight positions, with beads on four of them. It is started with a neat end and finished with end crimps. The beads are released one at a time during braiding.

Preparing the plate and threads

- Position the threads evenly across the hole in the plate as follows:
 Thicker threads: 5 across to ⑦ and 8 across to ⑥
 Thinner threads: 6 across to ⑧ and 7 across to ⑤
- Using a scrap piece of thread, tie the threads together at the hole in the plate with a lark's head knot to form a neat end (see page 23). Each warp will be 100cm (40in) long.
- Thread 46 beads on to each of the four thinner threads (see page 19). Wind all the threads on to bobbins.

Be a better braider

SKILL LEVEL 2

- If the hole in the pendant is too small to slide over the finished braid, you will need to add it at the halfway point. It may be easier to thread half of the beads, work the first side, fit the pendant and then thread and work the other half.
- When using a pendant with a metal finish, match the end crimps and clasp to the metal.
- **Front & back:** The front faces towards the braider, featuring the beads. There are no beads on the back.

1 Set up the plate as per the diagram and description above. Following braiding instructions as for the Orange Sherbet Bracelet (see page 36), work six rounds without beads to make a section that will go into an end crimp when the braid is finished.

2 Continue braiding, but now release a bead every time there are beaded warps at both ⑥ and ⑦. When each of these threads is moved up to 6 and 7 at the top, release a bead on each. This will occur twice in a row, so that a little cluster of four beads are worked into the braid. They will be locked in place on the following round. See page 20 for more on beading techniques.

3 Continue braiding until there are 46 clusters or the braid measures approx. 60cm (24in), finishing with six rounds without beads to match the start.

Adding a pendant

If you are adding a pendant that will fit over the beaded braid, it should be added before the end fittings are assembled. If the pendant will not go over the completed braid, stop at the halfway point, fit the pendant, reinstate the threads and beads and continue on. This method is also used to fit the tube bead to the Blue Bling Bead Necklace (see page 94).

Finishing

See page 26 for instructions on how to finish the braid with end crimps. Tweak the beads so they sit up nicely in their groups.
Finished size: The braid is about 60cm (24in) long and 6mm (¼in) wide.

Amber Eyes Necklace

The unusual threads wrap around the sides of each bead, and then come together to show off their textures in the main braid.

Technique
The braid has thread in eight positions, with beads on a separate (ninth) thread that alternates between the '7's. It is started with a neat end and finished with end crimps. The braid follows the same moves as the Pansy Eyes Necklace (see page 38), except the two right-hand threads, both top and bottom, are positioned and worked one slot along to the right.

Preparing the plate and threads
- Select the threads you wish to use from the skein of textured threads, or use two together at each position as here. Place the textured threads evenly across the hole in the plate as follows: 5, 6, 8, 9 across to ⑤, ⑥, ⑧, ⑨ in order listed
- Using one end of the rattail, tie the textured threads together at the hole in the plate with a lark's head knot to form a neat end (see page 23). Place the long end of the rattail into slot ⑦. Each warp will be 100cm (40in) long.
- Thread the beads on to the rattail (see page 19). Wind all the threads on to bobbins, using the medium bobbin for the beaded thread.

1 Main braid: Move ⑨ over to B and ⑤ over to ⑧. Move 6 down to ⑤, ⑥ up to 6 and 5 down to ⑥. Move 8 down to ⑨, ⑧ up to 8 and 9 down to ⑧. Move ⑧ up to 9 and B up to 5. Using only 7 and ⑦, swap the position of the beaded thread (this first time it will be from ⑦ up to 7). Repeat this entire sequence of moves for 4cm (1½in).

2 Eye of the braid: Move ⑨ up to ⑧ and ⑤ up to B. This is the move that separates the braid into two. Move 6 down to ⑤, ⑥ up to 6 and 5 down to ⑥. Move 8 down to ⑨, ⑧ up to 8 and 9 down to ⑧. Move ⑧ up to 9 and B up to 5. Keeping the left-hand threads on the left and the right-hand threads on the right, repeat this entire sequence of moves seven more times (making eight in total) or until the 'eye' of the braid is long enough to go around a bead.

3 Slide a bead into the braid and lock it in place by working three rounds of main braid (step 1). Continue until all the beads are in position, then work a main braid section until all the threads are used up.

Finishing
See page 26 for instructions on how to finish the braid with end crimps.
Finished size: The braid is about 50cm (20in) long and 12mm (½in) wide on the plain section.

You will need

- One skein of Colour Streams Textures (bundle of different textured threads) in Yellow comprised of eight 200cm (80in) lengths
- One 100cm (40in) length of 1mm rattail or satin cord in Goldenrod
- Eleven 16mm round beads with 1mm hole
- 12mm flat end crimps and clasp
- 8 small and 1 medium E-Z Bobs

Be a better braider
SKILL LEVEL 3

- The braid could be started with a 12.5cm (5in) plain section, followed by the beads, and finished with another 12.5cm (5in) plain section, with the end fittings positioned centrally at the back of the necklace.
- Vary the size of the 'eye' to fit any size bead.
- Adjust the size of the sections between the beads to give the desired effect.
- **Front & back:** The front faces towards the braider. The beads sit up higher on the front, making the back flatter.

Front Back

You will need

Five 200cm (80in) lengths of 1mm rattail or satin cord in Magenta

8g size 6 seed beads in Galvanised Gold (approx. 120 beads)

20g size 5 triangle seed beads in Crystal C/L Peony Pink (approx. 180 beads)

End caps with 6–7mm hole and clasp

10 small E-Z Bobs

Alternative thread: Imposter/Biron metallic kumihimo thread

Shimmering Princess Woven Collar

The threads weave their way around the shimmering golden and peony beads, forming sections of each colour. This design would be a perfect enhancement when wearing a plain top.

Technique

The braid has thread in 10 positions, with beads on the bottom five. It is started with a neat end and finished with end caps. The beads are released one at a time during braiding.

Preparing the plate and threads

- Position the threads evenly across the hole in the plate as follows: 5, 6, 7, 8, 9 across to ⑤, ⑥, ⑦, ⑧, ⑨ in order listed
- Using a scrap piece of thread, tie the threads together at the hole in the plate with a lark's head knot to form a neat end (see page 23). Each warp will be 100cm (40in) long.
- Thread approx. 60 beads (see page 19) on to the bottom warps as follows:
Gold: ⑤ and ⑥
Pink: ⑦, ⑧ and ⑨
Wind all the threads on to bobbins.

Be a better braider

SKILL LEVEL 2

- The length of braid worked without beads at the start and finish can be varied to suit the size of the end fittings being used.
- You could work a longer section without beads at the start and finish if you wanted to use fewer beads, particularly if these will be at the back of the necklace. Whichever way you choose, both ends should match.
- **Front & back:** The front faces away from the braider, with the beads raised evenly within the braid.

Front Back

1 Set up the plate as per the diagram and description above. Follow braiding instructions as for the Cool Green Bookmark (see page 44) to braid a 1cm (½in) section without beads. This will go into an end cap when the braid is finished.

2 Continue braiding, but now release a bead every time a beaded thread is moved from the bottom of the plate up to the top – that is, ⑥ up to 5, ⑦ up to 6, ⑧ up to 7 and ⑨ up to 8. Allow each bead to drop down the thread as the move is made. On the following round, make sure the thread being moved from B across to Ⓑ passes above the four beads. Refer also to 'Adding the beads' (opposite).

3 The following sequence of up/down moves of the top and bottom threads will lock the beads in place as follows: **BEAD** [⑥ to 5; 6 to ⑥] **BEAD** [⑦ to 6; 7 to ⑦] **BEAD** [⑧ to 7; 8 to ⑧] **BEAD** [⑨ to 8; 9 to ⑨].

4 Continue braiding until the beaded section is approx. 53cm (21in). Braid another 1cm (½in) without beads to match the start.

Finishing

See page 26 for instructions on how to finish the braid with end caps. Tweak the beads so they sit up evenly on the front of the necklace.
Finished size: The braid is about 56cm (22in) long and 17mm (11/16in) wide.

Adding the beads

The main diagram on the right shows a row of beads having just been released, one at a time, as each beaded thread is moved to the top of the plate. The first inset picture shows the side thread moved across from B to Ⓑ above the beads, holding them in place. The second inset picture shows the beads locked in place by the following sequence of up/down moves of the top and bottom threads. See page 20 for more on beading techniques.

1) Bead released on each beaded thread as it is moved to top of plate

2) Thread moving from left to right side of plate should go above all four beads

3) Following round of up/down moves separates and locks the beads in place

You will need

100cm (40in) lengths of 1mm rattail or satin cord in Light Blue:

3 lengths for beaded braid

5 lengths for plain braid

Two 200cm (80in) lengths of 1mm nylon braiding cord in Pale Blue

1 strand of 6mm round millefiori beads with 1mm hole in Soft Aqua (approx. 64 beads)

Two sets of 10mm flat end crimps and clasps

6 small and 4 medium E-Z Bobs

Alternative thread:
Imposter/Biron kumihimo thread

Pretty Bubbles Necklace

Like little bubbles floating down a stream of blue, the pretty millefiori beads sit on top of this woven braid. A plain blue braid is added with toggle clasps to finish the necklace.

Technique

The braid has thread in 10 positions, with beads on four of them. It is started with a neat end and finished with end crimps. The beads are released one at a time during braiding. The plain braid is made separately without beads.

Preparing the plate and threads

- For the beaded braid, place the threads evenly across the hole in the plate as follows:
 Rattail: 5 across to ⑤, 7 across to ⑦ and 9 across to ⑨
 Nylon cord: 6 across to ⑥ and 8 across to ⑧
- Using a scrap piece of thread, tie the threads together at the hole in the plate with a lark's head knot to form a neat end (see page 23). Each rattail warp will be 50cm (20in) long, each nylon warp 100cm (40in) long.
- Thread 16 beads on to each nylon warp (see page 19). Wind all the threads on to bobbins, using medium bobbins for the beaded warps.

Be a better braider

SKILL LEVEL 2

- The size of the beading thread is determined by the size of the hole in the beads.
- Use any 6mm round beads instead of millefiori beads.
- If using flat end crimps and toggle clasps as shown here, fit an extra jump ring on the bar side of the clasp to allow it to go through the hole more easily.
- **Front & back:** The front faces away from the braider, featuring all the beads. There are no beads on the back.

1 Set up the plate as per the diagram and description above. Follow braiding instructions as for the Cool Green Bookmark (see page 44) to braid a 5cm (2in) section without beads.

2 Continue braiding, but now release a bead every time a beaded thread is moved from 6 down to ⑥ and from 8 down to ⑧. Allow each bead to drop down the thread and hold in it place on the right side as the braid is worked behind it. The beads will sit on top of the braid rather than between the threads. Continue until all the beads are used up. See page 20 for more on beading techniques.

3 Braid another 5cm (2in) section without beads to match the start. The total length will be approx. 30cm (12in). Remove this braid and set aside.

4 Set up the plate with the five lengths of rattail and, using the same pattern, make a plain braid approx. 25cm (10in) long.

Finishing

See page 26 for instructions on how to finish each braid with end crimps. Tweak the beads so they sit up evenly on the front.
Finished size: The braids together are about 60cm (24in) long and 12mm (½in) wide on the plain section.

PROJECTS

You will need

- Reel of Nymo (size B) or nylon beading thread
- One 15m (16½yd) skein of Ophir hand-dyed fine silk thread in #11 Meadow
- Six 38cm (15in) strands of 6–7mm freshwater pearls in Smoky Green
- Size 8 seed beads:
 10g Galvanised Gold
 20g C/L Pale Topaz Sage AB
- End caps with 8mm hole and clasp
- 2 medium and 4 large E-Z Bobs
- Alternative thread: Use beading thread for both beads and pearls

Symphony of Pearls Necklace

This stunning freeform necklace is made from strings of beautiful freshwater pearls with strings of seed beads wandering among them.

Technique

The braid has thread in six positions, four with pearls and two with seed beads. It is started with a knot and finished with end caps. The threads are placed into the slots to get the braid started, then allowed to hang over the sides at the approximate positions.

Preparing the plate and threads

- **Pearls:** Rethread the pearls on to four lengths of beading thread. Use 1½ strands of pearls per thread, starting and finishing with 5 gold beads, and adding 1 gold bead after every 5 pearls. Use the beading thread doubled and with a length approx. twice the length of pearls.
- **Seed beads:** Cut two 2.75m (3yd) lengths of silk thread and fold each in half to use doubled. Thread half of the sage beads on to each doubled thread (see page 19), adding 1 gold bead after every 5 sage.
- Each warp will be 137cm (54in) long. Wind all the threads on to bobbins (small bobbins for the seed bead threads), leaving the cut ends free to tie together with an overhand knot (see page 18).
- Place the knot in the hole of the plate and position the threads in the slots as follows:
 Pearl threads: 4, 9, ⑤ and ⑧
 Seed bead threads: 6 and 7

Be a better braider

SKILL LEVEL 3

- Start the braid at the cut end of the threads, leaving the folded end free to add more beads or thread if necessary.
- Use a counterweight on the braid instead of holding it; then after about halfway, use small weights on the bobbins. The pearls are quite heavy and act as weights for most of the braiding.
- When tied together with the nylon beading thread, the silk thread gives some body to the braid to go inside the end fittings.
- **Front & back:** There is no difference between the two sides of this braid.

1 Set up the plate as per the diagram and description above. Follow braiding instructions as for the Funky Sneaker Laces (see page 32) to braid a 1cm (½in) section without beads or pearls. This will go into an end cap when the braid is finished.

2 Slide the beads and pearls along the threads up to the point of braiding. Continue braiding, allowing the threads to hang over the sides at the approximate slot positions. Towards the end, adjust the number of pearls so they all finish at the same time with gold beads.

3 Braid another section without beads to match the start.

Finishing

Remove the braid from the plate, tie the ends together with an overhand knot and fit the end caps (see page 26).
Finished size: The braid is about 60cm (24in) long and 25mm (1in) wide.

You will need

8m (8¾yd) skeins of Exotic Lights hand-dyed silk thread:

1 skein of #17 Jacaranda

2 skeins of #21 Purple Genie

69 size 5 triangle seed beads in Purple C/L Blue (approx. 5g)

15 tanzanite paddle beads (9 x 18mm)

10mm flat end crimps and clasp

8 small and 2 medium E-Z Bobs

Alternative thread: Any silk or rayon equivalent to pearl cotton #3

Purple Genie Necklace

This fabulous zigzag necklace takes its name from the lustrous hand-dyed silk thread it is braided with. Paddle beads hang from the points of the zigzags.

Technique

The braid has thread in 10 positions, with beads on two of them. It is started with a neat end and finished with end crimps. The beads are released three or four at a time by laying the thread across the braid.

Preparing the plate and threads

- Cut the skein of Jacaranda in half; only one of these is required for this project. Cut one skein of Purple Genie into three equal lengths. Cut a matching length from the second skein and save the remainder for another project.
- Position the threads evenly across the hole in the plate as follows:
 Purple Genie: 4, 5, 6, 7 across to ④, ⑤, ⑥, ⑦ in order listed
 Jacaranda: 8 across to ⑧
- Using a scrap piece of thread, tie the threads together at the hole in the plate with a lark's head knot to form a neat end (see page 23). Each Purple warp will be 132cm (52in) long, each Jacaranda 200cm (80in). Wind the Purple threads on to small bobbins.
- Thread the Jacaranda warps with beads (see page 19) as follows:
 Slot 8: 12 seeds, [3 seeds, 1 paddle] four times, 12 seeds
 Slot ⑧: [1 paddle, 3 seeds] 11 times
 Wind the beaded threads on to medium bobbins.

Be a better braider

SKILL LEVEL 3

- The silk thread is long enough to start with a plaited loop and finish with a tassel if you prefer.
- Re-tension the beaded threads when moving them from the side up to the top of the plate.
- If you only have small bobbins, thread the beads in batches rather than all at once, but make sure the seed beads are in multiples of three.
- **Front & back:** The front faces towards the braider, with the groups of three beads on top of the braid.

Front Back

1 Set up the plate as per the diagram and description above. Follow braiding instructions as for the Jazzy Jewels Necklace (see page 73) to braid a section without beads to go into an end crimp when the braid is finished. When the beaded threads return to their starting positions of 8 and ⑧, move B down to ④ and then turn the plate around so the circled numbers are at the top.

2 Move ⑧ over to ⑧ and 8 down to B. Allow three seed beads to drop down and lie across the braid as 8 is moved down to B. The following sequence of up/down moves will lock the beads in place as follows: [7 to ⑧; ⑦ to 7] **BEAD** [6 to ⑦; ⑥ to 6] **BEAD** [5 to ⑥; ⑤ to 5] **BEAD** [4 to ⑤; ④ to 4].

3 Continue braiding with the plate upside down until the beaded threads return to the right-hand side of the plate. Rotate the plate to the upright position. With the beaded threads now on the left, move 4 down to B and ④ over to ⑧. Allow the next group of four beads to drop as ④ is moved over to ⑧. They will lie across the braid with a paddle bead on the left – at the point of the zigzag – and then three seed beads.

4 The following up/down moves will lock the beads in place as follows: **PADDLE BEAD** [⑤ to 4; 5 to ⑤] **BEAD** [⑥ to 5; 6 to ⑥] **BEAD** [⑦ to 6; 7 to ⑦] **BEAD** [⑧ to 7; 8 to ⑧]. When a paddle bead is also dropped, this locking sequence will either start or finish

with the paddle bead, depending on the direction of the zigzag point being worked. Always release three seed beads at a time. If there is a paddle bead before or after the next group of three seed beads, then release that at the same time. If the beads have been threaded correctly at the start, you will not need to think about it as they will be in the correct place. Make sure all the beads are on the front of the braid.

5 Continue working the moves until the braid is approx. 50cm (20in). Turn the plate when the beaded threads return to the right-hand side. This will be 8 and ⑧ when the plate is the right way up, or 4 and ④ when it is upside down.

Adding the beads

The main diagram on the right shows a group of four beads – 1 paddle, 3 seeds – having just been released. The inset picture shows the beads separated and locked in place by the subsequent sequence of up/down moves made with the top and bottom threads. See page 21 for more on beading techniques.

Finishing

See page 26 for instructions on how to finish the braid with end crimps.

Finished size: The braid is about 50cm (20in) long and 10mm (3/8in) wide.

Paddle bead and three seed beads laid across braid

Beads locked in place by sequence of up/down moves of top and bottom threads

110 PROJECTS

Magical Dragon Bracelet

The use of metallic magatama beads, and the way they are threaded before the start of braiding, makes a very interesting pattern and texture resembling dragon scales. The addition of a dragonhead clasp completes this magical bracelet.

You will need

- Five 100cm (40in) lengths of 1mm rattail or satin cord in Magenta
- 15g long magatama 4 x 7mm drop beads in Gold/Violet/Green (120 beads)
- End caps with 6mm hole and clasp
- 10 small E-Z Bobs
- **Alternative thread:** Exotic Lights hand-dyed silk thread

Be a better braider

SKILL LEVEL 2

- The magatama beads have a diagonal hole, making the beads directional, so decide in advance which way they are to be threaded for the effect desired. Here, the beads were all threaded in the same direction and from the same side, so each row of four beads alternates direction when released.
- To calculate the length of the braid, deduct the length of the clasp from the required bracelet length.
- Make a plain braid in Magenta rattail and attach it to the beaded bracelet to transform it into a beautiful necklace.
- **Front & back:** The front faces towards the braid, featuring all the beads. There are no beads on the back.

Technique

The braid has thread in 10 positions, with beads on all of them. It is started with a neat end and finished with end caps. The beads are released four at a time by laying the thread across the braid.

Preparing the plate and threads

- Place the threads evenly across the hole in the plate as follows: 4, 5, 6, 7, 8 across to ④, ⑤, ⑥, ⑦, ⑧ in order listed
- Thread 24 beads on to each thread at the top of the plate (see page 19), making sure the beads all point in the same direction. Slide 12 beads on each thread across to the other side, so there are now 12 beads on each thread at all 10 positions.
- Using a scrap piece of thread, tie the threads together at the hole in the plate with a lark's head knot to form a neat end (see page 23). Each warp will be 50cm (20in) long. Wind all the threads on to bobbins.

1 Set up the plate as per the diagram and description above. Following braiding instructions as for the Strawberry Kisses Lariat (see page 46), work four rounds without beads to make a plain section to go into an end cap when the braid is finished.

2 Continue braiding, but now release the beads four at a time by laying them across the braid every time a thread is moved from 4 over to Ⓒ. When the next thread is moved from ④ over to Ⓑ, it should pass across the top of the beads. See page 21 for more on beading techniques.

3 The following sequence of up/down moves of the top and bottom threads will lock the beads in place as follows: **BEAD** [⑤ to 4; 5 to ④] **BEAD** [⑥ to 5; 6 to ⑤] **BEAD** [⑦ to 6; 7 to ⑥] **BEAD** [⑧ to 7; 8 to ⑦].

4 Continue braiding for 15cm (6in) or length required. Finish with another four rounds without beads to match the start.

Finishing

See page 26 for instructions on how to finish the braid with end caps.
Finished size: The braid is about 18cm (7in) long and 12mm (½in) wide.

Glitz and Glamour Necklace

Rhinestone tube beads and metallic thread are a perfect combination for this sparkly creation. If you need a bit more glitz, finish with a rhinestone clasp.

You will need

Two 2.7m (105in) long sections of Imposter/Biron kumihimo thread in #M3 Apricot Metallic Sparkle

Note: This thread can be bought in individual sections or a rope of 4; there is enough to make a considerably longer braid

47 x 9mm rhinestone tube beads with 4mm hole:

1 in Jonquil Topaz

2 in Jonquil Topaz/Silver

Four 12 x 9mm round rhinestone beads with 4mm hole

End caps with 5mm hole and clasp

4 small E-Z Bobs

Alternative thread: 2mm rattail or satin cord

Technique
The braid has thread in four positions. The beads are strung on to the centre of the threads and the two sides of the necklace are braided separately. It is finished with end caps.

Preparing the plate and threads
- Hold the two sections of thread together and fold in half. Thread the beads over the fold in the following order:
 1 round; 1 topaz/silver tube; 1 round; 1 topaz tube; 1 round; 1 topaz/silver tube; 1 round.
- Move the beads to the centre of the thread and cut the folded ends. Knot one side up close to the beads to hold them in place at the centre of the thread while working the first half of the braid.
- Pull the other end of the threads up through the hole in the plate so the beads and knot hang underneath.
- Position the threads in slots 6, 7, ⑥ and ⑦. Each warp will be 58cm (23in) long. Wind all the threads on to bobbins.

1. Set up the plate as per the diagram and description above. Work the first section of braid using the following moves: 6 over to Ⓑ, 7 over to B, ⑥ up to 6, ⑦ up to 7, B down to ⑥ and Ⓑ down to ⑦. Hold the braid when working it to prevent it from moving around. Continue braiding for 12.5cm (5in) or length required.

2. Remove the braid from the plate and whip around the finish end (see page 26), making sure it is secure. Clip the braid beside the first bead to prevent the beads from moving up the completed section of braid as you work the second section (a bulldog clip works fine).

3. To work the second section, allow the beads and completed side to hang under the plate and position the other end of the threads up through the hole in the plate and in the slots as before. Work the braid to match the first side, whipping around the finish end. Remove the clip.

Finishing
See page 26 for instructions on how to finish the braid with end caps.
Finished size: The necklace is about 43cm (17in) long and the braid 6mm (¼in) wide.

Be a better braider
SKILL LEVEL 3

- If a beading needle and leader thread will go through the tube beads, use this method to thread them (see page 19).
- Otherwise, twist the folded end of the threads to 'screw' the beads over the fold. Keep twisting and screwing until the thread can be pulled through.
- The braid will actually start forming inside the beads, allowing you to adjust the positioning of the beads when finished.
- **Front & back:** There is only a slight difference between the two sides of this braid. Choose the side you like best as the front.

PROJECTS

You will need

One 15m (16½yd) skein of Ophir hand-dyed fine silk thread in #38 Ocean Blue

160 Czech glass 4 x 6mm drop beads in Cobalt Vitrail

40 Rizo Czech glass 2.5 x 6mm beads in Silver

End caps with 4mm hole and clasp

10 small E-Z Bobs

Alternative thread: Any single-ply thread

Waterfall Bracelet

The metallic rainbow shimmer of the vitrail drop beads looks like light refracting through the droplets of a waterfall. Braided using hand-dyed fine silk thread and finished with a rhinestone clasp, this beautiful bracelet will make a fine addition to any jewellery box.

Technique

The braid has thread in 10 positions, with beads on all of them. It is started with a neat end and finished with end caps. The beads are released four at a time by laying the thread across the braid.

Preparing the plate and threads

- Cut five 100cm (40in) lengths of thread. Place the threads evenly across the hole of the plate as follows:
 4, 5, 6, 7, 8 across to ④, ⑤, ⑥, ⑦, ⑧ in order listed
- Using a scrap piece of thread, tie the threads together at the hole in the plate with a lark's head knot to form a neat end (see page 23). Each warp will be 50cm (20in) long.
- Thread 20 silver beads on to each warp at 6 and ⑧ (see page 19). Thread 20 cobalt beads on to each of the remaining eight warps. Wind all the threads on to bobbins.

Be a better braider

SKILL LEVEL 3

- To achieve the same pattern as the bracelet shown, the beaded threads must be back in the starting position when the beading is commenced.
- To make a 45cm (18in) necklace, you will need roughly 3 times the number of beads and thread used for the bracelet.
- If the bracelet requires stiffening, carefully paint the thread at the back of the braid with clear nail varnish or fabric stiffener.
- **Front & back:** The front faces towards the braider, featuring all the beads. There are no beads on the back.

1 Set up the plate as per the diagram and description above. Follow braiding instructions as for the Strawberry Kisses Lariat (see page 46) to braid a short section without beads, ending with the threads back in their starting positions. This section will go into an end cap when the braid is finished.

2 Continue braiding, but now release the beads four at a time by laying them across the braid every time a thread is moved from 4 over to Ⓒ. When the next thread is moved from ④ over to Ⓑ, it should pass across the top of the beads. See page 21 for more on beading techniques.

3 The following sequence of up/down moves of the top and bottom threads will lock the beads in place as follows: **BEAD** [⑤ to 4; 5 to ④] **BEAD** [⑥ to 5; 6 to ⑤] **BEAD** [⑦ to 6; 7 to ⑥] **BEAD** [⑧ to 7; 8 to ⑦]. Because the silver beads started at 6 and ⑧, the pattern will be: two rows of drop beads; one row silver; six rows of drop beads; one row silver. The pattern is finished with two rows of drop beads to match the start.

4 Continue braiding for 15cm (6in) or length required. This quantity of beads will make up to 18cm (7in). Finish with another plain section to match the start.

Finishing
See page 26 for instructions on how to finish the braid with end caps.
Finished size: The braid is about 16.5cm (6½in) long and 15mm (⅝in) wide.

You will need

200cm (80in) lengths of 1mm rattail or satin cord:
- 4 lengths of Turquoise
- 1 length of Green
- 1 length of Ivory

Size 6 seed beads:
- 20g S/L Blue AB (approx. 360 beads)
- 8g S/L Light Aqua AB (approx. 120 beads)
- 8g C/L Pale Topaz Sage AB (approx. 120 beads)
- 8g Galvanised Silver (approx. 120 beads)

End caps with 4 x 10mm hole and clasp

12 small E-Z Bobs

Goddess of Dawn Necklace

The inclusion of beads within a woven braid makes this a truly stunning piece. A longer braid in this design would make a fabulous belt.

Technique
The braid has thread in 12 positions, with beads on all of them. It is started with a neat end and finished with end caps. The beads are released one at a time during braiding.

Preparing the plate and threads
- Position the threads evenly across the hole in the plate as follows:
 Turquoise: 4, 5, 6, 7 across to ④, ⑤, ⑥, ⑦ in order listed
 Green: 8 across to ⑧
 Ivory: 9 across to ⑨
- Using a scrap piece of thread, tie the threads together at the hole in the plate with a lark's head knot to form a neat end (see page 23). Each warp will be 100cm (40in) long.
- Thread 60 silver beads on to each Ivory thread, 60 sage beads on to each Green thread, and 60 aqua beads on to each Turquoise thread at 7 and ⑦. Thread 60 blue beads on to each of the remaining six Turquoise threads (see page 19). Wind all the threads on to bobbins.

Be a better braider
SKILL LEVEL 2

- This design uses the 'B' slots when braided without beads, but you could use the 'A' slots instead as they work better when adding beads to the braid.
- Forgotten what the seed bead abbreviations mean? S/L = Silver Lined; C/L = Colour Lined; AB = Aurora Borealis.
- Paint the ends of the threads with clear nail varnish so you can thread the beads without using a needle.
- To make a 100cm (40in) belt, you will need roughly double the amount of threads and beads listed for the necklace.
- **Front & back:** The front faces away from the braider. The beads are slightly more raised on the front, and the direction of the pattern differs.

1 Set up the plate as per the diagram and description above. Following braiding instructions as for the Rainforest Necklace (see page 52), work one round without beads. This will go into an end cap when the braid is finished.

2 Continue braiding, but now release a bead every time a beaded thread is moved from the bottom of the plate up to the top. There will be five beads released in a row. Allow each bead to drop down the thread as each move is made.

3 When moving the thread from the left side of the plate across to the right after releasing a row of beads, make sure the thread passes above the five beads to hold them in position. See page 20 for more on beading techniques.

4 Continue braiding for approx. 53cm (21in). Finish with another plain section to match the start.

Finishing
See page 26 for instructions on how to finish the braid with end caps.
- **Finished size:** The braid is about 56cm (22in) long and 20mm (¾in) wide.

Dancing Fans Necklace

The beads are incorporated into the necklace in a particular sequence, forming little fans along the outer edge of this delicate braid.

You will need

8m (8¾yd) skeins of Exotic Lights hand-dyed silk thread:

1 skein of #1 Wisteria

1 skein of #17 Jacaranda

1 skein of #21 Purple Genie

176 size 8 seed beads in C/L Purple Fuchsia AB (approx. 6g)

10mm flat end crimps and clasp

12 small E-Z Bobs

Be a better braider

SKILL LEVEL 2

- Use a beading needle and leader thread to string the beads when using silk or a soft thread.
- To braid more fans, the lengths of thread will need to be cut longer. You will also need 16 extra beads for each extra fan.
- When making beaded braids, use the side slots that work best for your braid.
- **Front & back:** The front faces away from the braider. The beads are more even and slightly raised on the front.

Front Back

Technique

The braid has thread in 12 positions, with beads on seven of them. It is started with a neat end and finished with end crimps. The beads are released one at a time, forming a fan pattern.

Preparing the plate and threads

- Cut three 200cm (80in) lengths of Wisteria (palest colour), two 200cm (80in) lengths of Jacaranda (medium) and one 200cm (80in) length of Purple Genie (darkest).
- Position the threads evenly across the hole in the plate as follows:
 Wisteria: 4 across to ④, 5 across to ⑤, and 6 across to ⑥
 Jacaranda: 7 across to ⑦ and 8 across to ⑧
 Purple Genie: 9 across to ⑨
- Using a scrap piece of thread, tie the threads together at the hole in the plate with a lark's head knot to form a neat end (see page 23). Each warp will be 100cm (40in) long. Wind the threads at 8, 9, ④, ⑧ and ⑨ on to bobbins.
- Thread the beads as follows: 11 beads on to each thread at 4 and ⑤; 22 beads at 5 and ⑥; 33 beads at 6 and ⑦; and 44 beads at 7 (see page 19). This is a total of 176 beads. Each of the 11 fans requires 16 beads. Wind all the threads on to bobbins as you go.

1 Set up the plate as per the diagram (far left) and description above.

2 Following braiding instructions as for the Rainforest Necklace (see page 52), work three rounds without beads. The Purple Genie (darkest) thread will return to the right-hand side of the plate three times. Stop on the third round when the last Purple Genie thread is at Ⓑ (near left diagram). This non-beaded section will go into an end crimp later.

3 Continue braiding, but now release one bead at a time from the beaded threads to the left of the darkest threads. Release the beads when the beaded threads are moved from the bottom to the top of the plate. They will form rows of 4, 3, 3, 2, 2, 1 and 1 beads,

making 16 beads per fan. See page 20 for more on beading techniques.

4 Repeat this sequence of beading, starting every time the threads return to the positions shown in step 2. Continue braiding until all 11 fans have been worked, then finish with a plain section to match the start.

Finishing
See page 26 for instructions on how to finish the braid with end crimps.
Finished size: The braid is about 45cm (18in) long and 12mm (½in) wide at the beaded fans.

Sunset Splendour Necklace

These beads are interesting because they appear to sit on top of the braid. Variations in the thickness of the silk thread create a very slight texture in the braid.

You will need

- 15m (16½yd) skein of Ophir hand-dyed silk thread in #10 Venetian Sunset
- 240 Rizo Czech glass 2.5 x 6mm beads in Capri Gold (approx. 16g)
- End caps with 4mm hole and clasp
- 10 small E-Z Bobs

Be a better braider

SKILL LEVEL 3

- The skill level is advanced because the thread is very fine and the beads very light, making the braid more difficult to control.
- Because of the use of fine thread and very light beads, it is important to maintain a firm tension when working the beaded section.
- Thicker threads can loosen the slots in the kumihimo plate over time, so keep a separate plate for working very fine braids.
- If you make a mistake and have to undo the braid, read the steps in reverse, fix the problem, and continue on.
- **Front & back:** The front faces towards the braider, featuring all the beads. There are no beads on the back.

Technique

The braid has thread in 10 positions, with beads on all of them. It is started with a neat end and finished with end caps. The beads are released four at a time by laying the thread across the braid every second time a thread is moved from the left to the right side of the plate. The beaded sections are interspersed with plain rounds of braiding to help stabilise this very fine braid.

Preparing the plate and threads

- Cut eight 188cm (74in) lengths of thread. Two will be used single thickness, and the remainder in pairs.
- Place the threads evenly across the hole in the plate as follows:
 Double thread: 4 across to ④, 6 across to ⑥ and 8 across to ⑧
 Single thread: 5 across to ⑤ and 7 across to ⑦
- Using a scrap piece of thread, tie the threads together at the hole in the plate with a lark's head knot to form a neat end (see page 23). Each warp will be 94cm (37in) long.
- Thread 24 beads on to each warp (see page 19). Wind all the threads on to bobbins.

1 Set up the plate as per the diagram and description above. Following braiding instructions as for the Cool Green Bookmark (see page 44), work three rounds without beads. This end will go into an end cap when the braid is finished.

2 Move eight beads on each warp free of the bobbin so they hang down ready for releasing. As the thread is moved from B across to Ⓑ, allow four beads to drop down and lay across the braid. See page 21 for more on beading techniques.

3 The following sequence of up/down moves of the top and bottom threads will lock the beads in place as follows: **BEAD** [⑤ to 4; 5 to ⑤] **BEAD** [⑥ to 5; 6 to ⑥] **BEAD** [⑦ to 6; 7 to ⑦] **BEAD** [⑧ to 7; 8 to ⑧]. Work a complete round without beads.

4 Repeat this process (steps 2–3) until all the beads on the first lot of five threads have been used. Work four rounds without beads.

5 Repeat this process (steps 2–4) until all the beads on the second lot of five threads have been used, finishing with four plain rounds. Move the next group of eight beads free of the bobbins and continue working beaded and plain rounds as before.

6 Continue braiding for approx. 25cm (10in) until all the beads have been used. Work a plain braid for approx. 18cm (7in) long.

Finishing
See page 26 for instructions on how to finish the braid with end caps.
Finished size: The braid is about 45cm (18in) long and 6mm (¼in) wide.

Blue Sea Urchin Bracelet

Beautiful dagger beads in silvery purple make this unusual bracelet a must-have addition to your jewellery box. This one is finished with magnetic heart-shaped end caps to complete the bold statement piece.

You will need

- 8m (8¾yd) skein of Exotic Lights hand-dyed silk thread in #2 Water Nymphs
- 15m (16½yd) skein of Ophir hand-dyed fine silk thread in #2 Water Nymphs
- 200 Czech glass 3 x 11mm dagger beads in Purple/Silver
- End caps with 4 x 11mm hole and clasp
- 12 small E-Z Bobs

Technique

The braid has thread in 12 positions, with beads on the six finer threads. It is started with a neat end and finished with end caps. The beads are released one at a time during braiding.

Preparing the plate and threads

- Cut six 130cm (50in) lengths of the thicker thread (Exotic Lights) and six 200cm (80in) lengths of fine thread (Ophir).
- Using two matching threads per slot, position the threads evenly across the hole in the plate as follows:
 Fine thread: 4, 5, 6 across to ⑦, ⑧, ⑨ in order listed
 Thicker thread: 7, 8, 9 across to ④, ⑤, ⑥ in order listed
- Using a scrap piece of thread, tie the threads together at the hole in the plate with a lark's head knot to form a neat end (see page 23). Reposition the top and bottom threads with the thicker threads at the top and the fine threads at the bottom. Each thicker warp will be 65cm (25in) long, each fine warp 100cm (40in) long. Wind the thicker threads on to bobbins.
- Thread 33 beads on to each of the fine warps. Wind all the threads on to bobbins.

Be a better braider

SKILL LEVEL 2

- There is enough thread to make a braid approx. 30cm (12in) long.
- If braiding the full length of the threads, you will need approx. 400 beads.
- Match the thickness of the fine thread with the hole in the beads.
- Want to try an alternative method of starting with a neat end? Simply link the two groups of threads together at their midpoint by wrapping one group around the other, then place the individual threads into the appropriate slots. Tie a scrap of thread around the centre so that there is something to hold at the start of braiding.
- **Front & back:** The front faces towards the braid, featuring all the beads. There are no beads on the back.

1 Set up the plate as per the diagram and description above. Follow braiding instructions as for the Golden Dreams Necklace (see page 50) to braid a 1cm (½in) section without beads. This will go into an end cap when the braid is finished.

2 Continue braiding, but now release a bead every time the beaded threads are moved up to the top of the plate. On the following round, when the thicker threads are moved up to the top of the plate once more, they will lock the beads in place. Refer also to 'Adding the beads' (opposite).

3 Continue braiding until the beaded section is approx. 16.5cm (6½in) or length required. Work a plain section to match the start.

Finishing

See page 26 for instructions on how to finish the braid with end caps.

- **Finished size:** The braid is about 19cm (7½in) long and 20mm (¾in) wide.

Adding the beads

The main diagram on the right shows a row of beads having just been released, one at a time, as the fine threads are moved to the top of the plate. The inset picture shows the beads secured in place on the following round, when the thicker threads are moved back up to the top of the plate. See page 20 for more on beading techniques.

As fine threads are moved to top of plate, beads are released and slide down against braid

Beads are locked in place when thicker threads are moved to top of plate on following round

Forest Glen Ensemble

Three projects in one! The first is the bracelet with four rows of drop beads that look like they have been gathered from the forest floor. The necklace is worked next, with the beads just on the edges. The two can then be connected to wear as one longer necklace.

Technique

The braid has thread in eight positions, with beads on the four finer threads. It is started with a knot and finished with end caps. The beads are released one at a time during braiding. The bracelet and necklace are made as one long braid, and then separated.

Preparing the plate and threads

- Cut four 200cm (80in) lengths of the thicker thread (Exotic Lights) and eight 188cm (74in) lengths of fine thread (Ophir).
- Tie all the threads together at one end with an overhand knot (see page 18). Place the knot in the hole of the plate and position the threads in the slots as follows:
 Thicker thread: 5, 6, 7 and 8 (one thread per slot)
 Fine thread: ⑤, ⑥, ⑦ and ⑧ (two threads per slot)
- Each warp of thicker thread will be approx. 200cm (80in) long, each fine thread 188cm (74in) long. Wind the thicker threads on to small bobbins.
- Thread 80 drop beads on to each fine thread (see page 19) and wind on to medium bobbins.

You will need

- 8m (8¾yd) skein of Exotic Lights hand-dyed silk thread in #11 Meadow; the bracelet alone uses four 50cm (20in) lengths
- 15m (16½yd) skein of Ophir hand-dyed fine silk thread in #11 Meadow; the bracelet alone uses eight 60cm (24in) lengths
- 320 Czech glass 4 x 6mm drop beads in Turquoise Picasso (140 for bracelet; 180 for necklace)
- Two sets of end caps with 5mm hole and clasps
- 4 medium and 4 small E-Z Bobs

Be a better braider

SKILL LEVEL 2

- Re-tension the beaded warps every time they are at the top of the plate so the beads sit correctly (see page 17).
- To make the whole braid the same as the bracelet would require an extra 180 beads.
- With this amount of thread, the necklace could be up to 60cm (24in) long.
- **Front & back:** The front faces away from the braid, featuring all the beads when working the bracelet. On the necklace, the beads stand up along the edge of the braid.

Front Back

Bracelet

1 Set up the plate as per the diagram and description above. Follow braiding instructions as for the Tutti-Frutti Bracelets (see page 34) to braid a 1cm (½in) section without beads. This will go into an end cap when the braid is finished.

2 Continue braiding, but now release a bead every time the beaded threads are moved to the top of the plate. On the moves from ⑥ and ⑦, the beads will sit between the braid and the back of the hole in the plate. On the moves from ⑤ and ⑧, the beads will tuck under the side threads, and will then be caught in place when the side threads are moved to the bottom of the plate. Refer also to 'Adding the beads' (opposite).

3 Continue braiding until the beaded section is approx. 16.5cm (6½in) long. Work a plain section approx. 2cm (¾in) long without beads. This will later be cut in half to separate the bracelet from the necklace.

Necklace

4 Start working a beaded braid again, but this time, only release a bead on the moves from ⑤ and ⑧. Work the necklace section for 43cm (17in). Finish with another plain section to match the start.

Adding the beads

The main diagram on the right shows two beads having just been released at the centre of the bracelet braid. Beads are only released on this move for the bracelet, not for the necklace. The first inset picture shows what the bracelet looks like after the second pair of beads have been released on the edges of the braid; these are tucked under the side threads. This is the only beading move made on the necklace, and you can see what it should look like in the second inset picture. See page 20 for more on beading techniques.

1) **Bracelet:** Beads released on centre threads sit between braid and back of hole in plate

2) **Bracelet:** Beads released on outer threads should tuck under the side threads

Necklace: Pair of beads released on outer threads only

CONTINUED ON PAGE 126 ▶

Finishing
Remove the braid from the plate and knot the finish end. Whip around the plain section between the two braids twice (see page 26) and cut between the two lots of whipping. Fit the end caps so each piece can be worn separately or together.

Finished size: The bracelet braid is about 19cm (7½in) long, the necklace 45cm (18in) long. Both are 15mm (⅝in) wide.

Index

A
Amber Eyes Necklace 100–101

B
back of braid 7
bag jewellery 15
beaded braids 7
 projects 90–126
 releasing beads one at a time 20
 releasing multiple beads 21
 testing a design 15
 things to watch for 21
 threading beads on to braiding thread 19
beaded tassels 27
beading tools 11
beading wire 13
beads 14
 adding to a braid 20–21
 estimating quantities 15
 threading on to braiding thread 19
 types of bead 14
belts 15
Blue Bling Bead Necklace 94–95
Blue Ice Bracelet 42–43
Blue Sea Urchin Bracelet 122–123
Blue Skies Chevron Braid 62–63
bobbins 10, 11
 using 16, 19
bookmarks 44–45, 56–57, 62–63, 70–72
bowls 15
bracelet and necklace ensembles 40–41, 66–67, 88–89, 124–126
braid length, calculating 15
braid projects:
 beaded 90–126
 non-beaded 30–89
 wire 86–89
 zigzag 70–87, 108–109

C
Carnival Necklace 96–97
Chequerboard Choker 84–85
clasps 11
connector bead, finishing with 23
Cool Green Bookmark 44–45
correcting mistakes 16
Crazy Zigzag Necklace 78–80
curtain ties 15
Czech glass beads 14

D
Dancing Fans Necklace 118–119
decorations 15
decorative knots 15
designing braids 15
 measurements 15
 things to make 15
diagrams, following 7
double overhand knot, finishing with 25

E
E-Z Bobs 16
embroidery silk 12–13
Emerald Princess Necklace 90–91
end caps, finishing with 26
ends:
 end sets 11
 finishing with end crimps/caps 26
 self-assembled findings 11
equipment 10, 11

F
Fairy Meadow Necklace 54–55
findings 11
finishing braids:
 with beaded tassel 27
 with connector bead 23
 with double overhand knot 25
 with end caps 26
 with flat end crimps 26
 with overhand knot 22
 with plaited tails 25
 with tassel 27
Flame Interlaced Necklace 81–83
flat end crimps 11
 finishing with 26
Forest Glen Ensemble 124–126
friendship bracelets 30–31, 34–37, 40–43
frogging 15
front of braid 7
functional knots 18–19
Funky Sneaker Laces 32–33

G
Gilded Dragonfly Ensemble 88–89
Glitz and Glamour Necklace 112–113
glue 11
Goddess of Dawn Necklace 116–117
Golden Dreams Necklace 50–51
Grapevine Choker 48–49

H
hand-dyed embroidery silk 12–13
hand-dyed ribbon 13
Harvest Moon Choker 92–93

J
Japanese flat end sets 11
Japanese seed beads 14
Jazzy Jewels Necklace 73–75
Jewel Cuff 60–61
jewellery 15

K
key rings 15
knots:
 double overhand knot 25
 lark's head knot 18
 overhand knot 18
 reef or square knot 19
knotted fastening loop, starting with 25
kumihimo round discs 10, 128
kumihimo square plates:
 holding 16
 rotating 16
 setting up 7, 16
 sizes 10
 template for 128
 types 10
 using side slots 21
 working braid with 17
kumihimo threads 12
 using 13

L
laces 32–33
Lacy Wired Necklaces 86–87
lanyards 15
large-holed beads 14
lark's head knot 18
leader thread 19
Long and Short Zigzag Necklace 76–77

M
Magical Dragon Bracelet 110–111
magnetic end caps 11
materials 11
metallic threads 12
mistakes, correcting 16
My First Friendship Bracelets 30–31

N
neat end, starting with 23
necklace and bracelet ensembles 40–41, 66–67, 88–89, 124–126
needles 11
nylon braiding cord 12

O
Orange Sherbet Bracelet 36–37
overhand knot 18
 starting and finishing braids with 22, 25

P
Pansy Eyes Necklace 38–39
pearl cotton 12
pearls 14
pendants 14
Peppermint Leaves Ensemble 40–41
plain (non-beaded) braids 30–89
plaited loop, starting with 24
plaited tails, finishing with 25
plant holders 15
point of braiding 16
Pretty Bubbles Necklace 104–105
Purple Genie Necklace 108–109

Q
quantities, estimating 15
Quilted Ensemble 66–67
Quilted Variations 68–69

R
Rainforest Necklace 52–53
rattail 12, 13
rectangular end sets 11
Red and Gold Bookmark 56–57
reef knot 19
re-tensioning thread 17
ribbon 13
Rickrack Bookmark 70–72
rotating the plate 16
round beading wire 13
round kumihimo discs 10, 128
round end sets 11
Royale Necklace 98–99

S
satin cord 12
scissor keepers 15
seed beads 14
self-assembled findings 11
semiprecious beads 14
Shimmering Princess Woven Collar 102–103
shoelaces 15, 32–33
skill level 7
Sonata Ribbon Necklace 58–59
square knot 19
square kumihimo plates 10
starting braids 16
 with knotted fastening loop 25
 with neat end 23
 with overhand knot 22
 with plaited loop 24
stopping during braiding 16
Strawberry Kisses Lariat 46–47
Sunset Splendour Necklace 120–121
Sunshine Necklace 64–65
Symphony of Pearls Necklace 106–107

T
takadai 10
tassel, finishing with 27
techniques:
 beads, adding to braid 20–21
 beads, threading on to braiding thread 19
 correcting mistakes 16
 E-Z Bobs, using 16
 functional knots 18–19
 holding the plate 16
 re-tensioning thread 17
 rotating the plate 16
 setting up the plate 16
 side slots, using 21
 stopping and starting 16
 working the braid 17
template 128
tension 10, 17
testing a design 15
textured thread 13
things to make with braids 15
threading beads on to braiding thread 19
threads 12–13
 calculating length of 15
 leader thread 19
 thread for beaded braids 12–13
 whipping thread 11
 using kumihimo thread 13
Three Quilted Variations 68–69
tigertail wire 13
tools 11
tube beads 14
Tutti-Frutti Bracelets 34–35

W
warps 15
Waterfall Bracelet 114–115
weights 11
whipping:
 around ends of braid 26
 around plaited loop 24
 around tassel 27
 strong thread for 11
wire 13
wire braids 86–89

Z
zigzag braids 70–87, 108–109

Credits

I would like to say a big thank you to my family and friends for being so supportive and for encouraging and inspiring me throughout this journey. A special thank you to my sister Margaret, who was always ready for another show and tell.

Again, thanks to the team at Quarto for having the vision for this second book. It is always a pleasure to work with you.

Thanks to Donna McKean of Riverside Beads for being my hands for the step-by-step techniques.

Finally, to my students and customers, a special thanks for your enthusiasm.

Quarto and the author would like to acknowledge Makiko Tada, the creator of the original handheld kumihimo plate. Makiko's braiding patterns and diagramatic instructions are the inspiration for some of the braids in this book. Reproduced designs and diagrams appear on pages 42–45, 50–55, 60–61, 73–77 and 81–89 by permission. Makiko's braids can be found in *Comprehensive Treatise of Braids VI: Kumihimo Disk and Plate* by Makiko Tada, first published in October 2007 by Texte, Inc.

All photographs and illustrations are the copyright of Quarto Publishing plc. While every effort has been made to credit contributors, Quarto would like to apologise should there have been any errors or omissions – and would be pleased to make the appropriate correction for future editions of the book.

Suppliers

All of the materials used in this book are available, either individually or in kit form, from Beth at:
- **Braid and Bead Studio**, www.braidandbeadstudio.com

If you have any queries, or would just like to share your creation, please feel free to email Beth at: beth@braidandbeadstudio.com

Other suppliers of kumihimo tools and materials include:
- **BraidersHand** (USA), kumihimo threads and equipment, www.braidershand.com
- **Carey Company** (UK), kumihimo threads, www.careycompany.com
- **Colour Streams** (Australia), silk threads, www.colourstreams.com.au
- **Cranberry Beads** (Australia), seed and Czech beads, www.cranberry.net.au
- **Stef Francis** (UK), silk threads, www.stef-francis.co.uk

Template

Use this template to make your own cardboard plate. It can be enlarged, or have fewer slots, depending on your needs (see page 10).

If you would like to learn more about using the round kumihimo disc to make other types of braids, see Beth's earlier book in this series: *Twist, Turn & Tie: 50 Japanese Braids*.